DRAMA SCHOOL

THE COMPLETE HOWTODRAMA.COM GUIDE ON GETTING IN AND WHETHER IT'S RIGHT FOR YOU

BY CONOR MCGRATH

A NOTE ON THE AUTHOR

Conor McGrath is the head editor of HowtoDrama.com and one of the founding members of the company that created a lot of the initial content in 2015. Conor regularly reviews all the free articles on the website and has taken a key roles in content creation, marketing and growth of the company. Since its inception Conor and HowtoDrama.com have grown into a key player in publishing great content, delivering value and shaking up the world of online resources for Actors.

Often Acting can be shrouded in confusion and sometimes secrecy because of the amount of gatekeepers and grey areas in the industry. Conor's goals in writing and contributing to content produced by HowtoDrama.com is to make sure that those who want to gain the right information can have it.

Acting can be such a fulfilling and wonderful career for those who manage to make it a vocation. It is more than just a profession and for those that make it can become a lifelong craft that brings such joy and fulfilment.

Table of Contents

ACKNOWLEDGMENTS	11
Introduction	12
There is good news and bad news...	13
What can you do about it?	15
Should you train at Drama School?	17
What makes a successful Actor?	18
Laziness	19
Kindness	21
Theatre - preparation, preparation, preparation	22
Watching Hamlet at 17	25
The Royal Court Theatre	26
Getting the book bug	28
British Theatre: Heritage and History	29
Fringe Theatres	31
Theatre Companies	34
Examples of Fringe companies	35
Frantic Assembly	36
Notable other Theatre Companies	37
Defining Contemporary and Classical speeches	38
The Golden age of British Theatre - Shakespeare	39
20th century Theatre	42
My Mistake	46
What makes it a contemporary speech?	47

The Do's and Don'ts of the getting of monologues	48
Golden Rule	51
Choosing a Contemporary speech	51
An Actor Prepares	54
The problem...	55
Personality test	56
Introduction to Shakespeare and the classical speeches 59	
Non-judgemental Attitude towards Shakespeare	63
Exercise:	64
Books to read	66
Plays	68
Choosing a character	70
Which one to Choose?	73
What to do once the right speech comes along	75
The Basics of performing Shakespeare	76
Golden Rule	79
Translating Shakespeare	79
The way to "decode" Shakespeare	80
How to prepare a speech	83
Units and Objectives	84
What is a unit?	86
What is an Objective?	87
Actioning	88
Breaking down the script	88
List of Acting Exercises	89
Given Circumstances	92
Performing the speech	94

Choosing a song	96
Good singers	98
Bad singers	103
Conclusions	104
Choosing a school	105
Advantages to Training in London	105
Disadvantages to Training in London	106
Advantages to having a "name" behind you	107
Disadvantages to going to an old Institution	108
Conclusions	109
List of Schools	111
Voice	113
The problems with teaching voice from a book	114
Power	115
Relaxation	116
Articulation	117
Resonance	118
Conclusion	120
Body	121
Keep active	123
Mindset and Audition Technique	125
How to act in the room	126
How to deal with nerves	127
The Exception to the Rule	130
What Some Other People do	131
How to not forget your lines	132
What to do on the day	134
What if I have to sight read?	135

Process - How to apply	136
Audition Fee	137
Personal Statements	138
Head shots	142
My experience	143
The Exception	144
What's going to happen after Drama school? - Big picture	145
Jobs	148
Additional Help	150
Further Reading	151

BY THE SAME AUTHOR

HOWTODRAMA.com has produced two books which cover everything that needs to be known about the craft of Acting and also the process of applying and getting into Drama school. The company is dedicated to providing the best knowledge for those people who truly aspire to make the craft of acting their profession.

We have a creative team, contributors as well as editors who research and collaborate to create the best content. This book was 3 years in the making and came about from that process within the team.

Getting into Acting - Howtodrama.com guide
Getting into drama school - Howtodrama.com guide

HOWTODRAMA.COM

LONDON, LA, NEW YORK

**FIRST PUBLISHED IN 2017 BY HOWTODRAMA.COM ON AMAZON
COPYRIGHT @ HOWTODRAMA.COM AND CONOR MCGRATH
THE MORAL RIGHT OF THE AUTHOR HAS BEEN ASSERTED
HOWTODRAMA.COM, HIGH ROAD, FINCHLEY, N129QD**

HOWTODRAMA.COM IS A TRADEMARK OF HOWTODRAMA.COM AND HTD

**LONDON, NEW YORK, LA
PRINTED AND BOUND BY AMAZON**

WWW.HOWTODRAMA.COM

"I would rather be ashes than dust!
I would rather that my spark should burn out in a brilliant blaze than it should be stifled by dryrot.
I would rather be a superb meteor, every atom of me in magnificent glow, than a sleepy and permanent planet.
The purpose of man is to live, not to exist.
I shall not waste my days in trying to prolong them.
I shall use my time."

- Jack London

ACKNOWLEDGMENTS

All the chapters and articles in this book come from the creation of the HOWTODRAMA.COM brand and the website that goes along with it. The book is the result of many contributing writers and years of content being created online and in print form. It is a project that has taken years to become a reality and took a lot of effort in order to come about.

I would like to thank all the teachers and mentors that got me to this point. Not only those who helped me in my Acting career but also those that helped be build and run the business. There were many times when I wanted pack it all in and give up but it is those that persevere who reap the rewards.

Like I try to stress in all my articles and in my writing: nothing in life nothing is wasted if done with passion. This publication is certainly an example of something produced with passion. Thank you to the team at HOWTODRAMA.COM and also to those editors and poor souls who had to put up with my incessant neuroticism.

Introduction

I have been where you are now, I was a young dreamer who was trying to decide what path I should follow for my future. With the support of some fantastic teachers and from my family I settled on an unwavering desire to become a professional Actor. I assume those of you reading this book are of the same ilk. You will be thinking about Acting as a vocation - one that requires accredited training - whether you are for UK based, US or elsewhere.

When I was considering training I read every single book on the subject and I prided myself on getting my hands on as much information as possible. I looked at books on Amazon; I watched every YouTube video on Drama School; I read the Drama UK advice bulletin and I scoured magazines and newsletters to find great teachers.

Despite the gargantuan amount of effort I put into planning and after working extremely hard it took me 2 years to get into the Drama school I wanted to attend. Looking back that makes me realize how competitive the industry is and how difficult it is to get a footing on the first rung of a tall ladder.

I know how hard it is and I know that there is very little reliable help out there for you.

There is good news and bad news...

The good news is that you are headed in the right direction. The fact that you are reading this book means that you are actively trying to educate yourself and better your understanding of the craft of Acting. Hopefully you are seeking advice from people who have more experience or are supportive - that can only be a good thing.

By buying this book you have invested in your education and by doing that you have taken a practical step towards your goal. I would encourage you to keep taking those steps. Steps might seem very small at the beginning - right now you need to get into Drama school but in the future that could be invaluable and aid to something bigger.

Try to not frustrate yourself by only judging yourself positively by getting the result. Ultimately it is not big actions that amount to success but small daily rituals practiced over many years. That means you must be patient with yourself and patient with others.

As long as you tread that narrow path of constant self-evaluation, progress and patience then there isn't a force in the world that can stop you.

The bad news...

The bad news is that getting into Drama school is becoming more and more competitive each year. Entry is not guaranteed today or any time in the future. People arrive in preliminary auditions with extensive experience from public schools and in rare cases professional experience. Statistically getting into Drama school is one of the most competitive higher education degrees out there with hundreds of applicants going for one spot in some cases.

This isn't meant to be off-putting or scary, it is just the reality of the situation. The entire performing Arts industry is saturated and Drama school is only the beginning of lengthening odds. Often the people who

only have a half-hearted dedication fall at the first hurdle and that is probably for the best considering.
The bottom line is that it is tough.

What can you do about it?

There is no getting past it: the better quality of information and training you receive the better at something you will be. This is no different in Acting as it is in anything in life. The standard is getting higher every year and if you aren't keeping up with the competition you will be left behind. So you must carry on with whatever momentum possessed you to seek out the knowledge in this book. In fact you must go way beyond it and sustain it throughout your career. Seeking guidance in nuggets of gold as well as long slogs of just repeating the fundamentals.

I am testimony to the fact that it can be done. I have enjoyed a career doing something that I care for and now my goal is to set my knowledge in black and white for others to learn from. If you are someone who has a real calling to be an Actor then I hope this book guides you during that journey. I've been taught by some incredible teachers, I have studied at two of the best Drama schools if not the best Drama schools in the country and I have written this to help those who want to do the same. If that is you then brilliant!

What is great, for yourself and for others that read the book, is that I practice what I preach and have done so in the past. I'm not someone who's taught Drama at the "Failed Performers Guild" (FPG) for the past 20 years and has now decided to write a book on "Auditioning: A Guide to the Actor's inner depths". I've been on the West End, I've done TV, film and I started with my first gut wrenching rejections from every single Drama School.

I want to make sure you don't have to make the mistakes I made - I won't lie to you I made a lot. This book is specifically going to be about my experience getting into Drama school and getting the skills to become a professional Actor. There will be a lot of paragraphs which I will struggle not to type in BOLD CAPITALS because of the pain that it caused me by not following such advice. The book is strewn with life advice as well as

specific Acting jargon. I shall endeavour not to preach but give solid and practical advice but apologies in advance for some strained control!
A favourite teacher of mine once said: "Acting is a great profession but a shit career"

I will try to prove in this book that with the right guidance a wonderful career is possible and that Drama school may be the first tentative step to that end.

Should you train at Drama School?

This, if you haven't found out already, is a tough profession. But you've made an intelligent choice by wanting to apply for a Drama school. Vocational training is unlike qualifications in a lot of professions nowadays. In certain fields a degree is becoming less and less valuable by the year because of saturation. However, a graduate from a good Drama school has a great foundation of knowledge to work from.

Of course not everyone becomes a success - which is something this book will cover - but it certainly is not a waste of time even if that path leads to a dead end. In my opinion, Drama school is an intelligent investment and something that I do not regret going through.

This does not mean that it is a magic bullet. Much like all other industries there is intense competition to get accepted and that is only the start of a long journey of hustling from the bottom. One thing to think about when you are standing in a fork in the road is the likelihood of success down each path. The ultimate goal of going to Drama school is to become a fully-fledged Actor. It helps to know exactly what that entails.

What makes a successful Actor?

You need to be made of the right stuff. There is no question that if you want to be a professional Actor then Drama school is a tried and tested method to make it so - that is a given. I won't go into much more detail on that point. By getting this book I assume you are weighing up other options. There are avenues such as work experience, DIY classes or weekend groups but this book focuses on the most popular: accredited and vocational two or three yearlong Degrees/Masters in Acting.

The question is not whether Drama school is right for you - you want to be an Actor after all - but rather are you right for professional Acting? Have you got what it takes?

You may want to be a pro Actor more than anything else in the world; your wishes may be sincere; you may be a very hard working individual with bags of talent and you might have a supportive family that helps you every step along the way.

You might also have a fantastic degree from a first-rate Drama school.

However, unless you have an unwavering belief in yourself and a dedication to ride through rough times then all of the above doesn't mean anything.

I would say belief in your self-worth and faith in your talent is paramount in this industry. It is something that no one can wrench from you if you hold it tightly enough. The most successful Actors are similar personalities and they have completely different roads that led them to where they are. Some are reserved and modest whereas others are bombastic and fabulous. There may have been times when they were down-in-the dumps or unable to pay the rent but all held onto their belief. That is the common denominator and something you need to seriously consider in your own character.

Laziness

In this book there will be practical exercises and advice that you can choose to follow or not. As well as that you might go to a Drama school where you will be pushed to your extremes on a daily basis and then leave and never need to Act again. Do not be surprised if you don't get a call back in the real world if you cut corners at any point.

The sheer number of applicants means that for any point you chose not to go over some lines or take an extra class there is someone out there who did. People can smell a lazy Actor from a mile off. It is not a scent that is met with enthusiasm. I won't labour on this point, I'm sure you aren't a character that this needs to be said repeatedly to, but laziness costs those who indulge in it.

You may have the best of intentions but in showbiz, like with anything, you have to put in the time and the work before you get any results. Acting is learnt by DOING! Do not think that you can sit in your bedroom, read this and then walk into the audition room and nail it. There is going to be a lot of practical advice from start to finish and if you do not implement it then you will not get the result you want – PERIOD.

No one is a voluntary babysitter if you want this bad enough you will follow what I say, if you don't then you will join the thousands of other people who blame their incompetence of the fates.

Kindness

In saying this you must also remember to be kind to yourself above all else. You are going for something that you are really passionate about and nothing is wasted if done with passion. There are going to be people who might not understand your motivations in going into this career. Even people who do understand may not like it out of spite. In my experience even with supportive friends and family I still had bumps along the way. I would encourage you to try to hold onto your enthusiasm and curiosity. No one can take that away from you unless you let them and it helps to be your own best critic.

Whatever happens I wish you the best of luck in your endeavour for Drama School and I hope that I see you on the stage in the future!

Let's begin.

"The Actor should be able to create the Universe in the palm of their hands" - *Laurence Olivier*

Theatre - preparation, preparation, preparation

If you are not watching Theatre regularly then you are missing an opportunity to study the fundamentals of Acting. The immediateness of live Acting as well as the immersive environment of watching a play is a unique experience. It is the building blocks for people who are passionate about the craft of Acting and essential for those starting out.

When I was applying to Drama school and to this day I watch Theatre at least every two weeks. As I write this sentence I am on the London underground going to watch a show at the National Theatre. I cannot think back to a time where I wasn't regularly going to see shows and liaising with the crowd that comes with them.

While I was in sixth form/high school I would take the train up to London to get standing tickets to West End shows. By paying around five pounds for a standing ticket I could afford one show a week as well as the train fare. I would then get home late at night and then read the play if I absolutely loved it. I would do that as often as I could and still do it whenever I have time now. I suggest you start to do the same because that is the level of dedication you need.

The reason I emphasize Theatre is because watching a live show is not the same as sitting down and watching a film. Film is a medium that has given us some of the greatest Actors and performances of our generation whether that be home grown talent or imported films. The litany of British Acting stars include some of the all-time greats: Meryl Streep, Ian McKellen, Judi Dench, Richard Burton, Laurence Olivier and the list could go on. However, notice that all of those names have a strong Theatre background whether or not that is what they are primarily known for. Judi Dench spent years in the Royal Shakespeare Company before she had her first part on the screen.

I will admit that, as a medium, film is more influential to the masses but that does not mean it is the best place to cut your teeth. For an Actor the best place to watch the masters, digest the knowledge and learn the ropes is on the boards of a stage.

Even if we are to look at some brilliant American Actors the common denominator is Theatre. Marlon Brando is mostly known for his film work but he had a litany of Broadway performances in Antigone and A Streetcar Named Desire as well as his film roles.

Even if you aren't enthusiastic about watching live shows it is important to know that drama Schools are primarily interested in training you through the medium of Theatre. If you are not familiar with that medium then you are at a significant disadvantage.

Of course you will want to leave and have a career littered with TV and Film jobs but Drama Schools want to train you through the medium that gives the actor the most chance to stretch and develop their skills – that is unquestionably Theatre.

You need to start watching plays in fringe theatres, at the National, at your local theatre, amateur theatre, pub shows, musicals, and monologue slams – anything that is exposing you to the industry. Not only will this mean that you will have something to talk about when you get into the audition room but you will see what material works, what parts you are drawn to and what you like and dislike.

This is not something that I can give exercises for it is something that you will have to take responsibility for. It is a habit that you will have to build and schedule around your lifestyle. I had to budget and organize my trips much like you will have to as well.

Watching Hamlet at 17

When I was applying for Drama school I used to take the train up to London after school in order to see plays at the National Theatre. One of the most memorable productions I ever saw was the famed Hamlet. It was the first time I ever saw the production - certainly not the last. It was at the Young Vic on a school night with Michael Sheen playing the title role. I had never read Hamlet before and I only went up because they had an offer for student tickets on that night. I loved the production so much that I went home and read the entire play from cover to cover until 3 in the morning. I learnt the monologue "O, that this too too sullied flesh" after that night and used it for some of my auditions.
That is the level of dedication you need!

This is my favourite way of finding speeches for auditions: Drama school or otherwise. The reason I was so successful with this speech was because I had a lot of passion for it. I had this whole experience of watching Hamlet for the first time and discovering it in a very personal way. Staying up at night and getting my teeth into it meant that I performed it better. Now you obviously you do not need to see a play to find a monologue.

You can either read a fantastic piece or pick one straight out of a monologue book if you are feeling lazy. There is a whole host of ways to find good content. For Drama school applicants the next best thing to do is to read plays.

The Royal Court Theatre

The Royal Court Theatre has been the centre of new writing for the past 60 years and they have a dedicated team that reads 200 new plays a week with the goal of developing them and putting them on. In terms of finding contemporary writing, you cannot go wrong with the Royal Court.

Go on Wikipedia and find the list of plays that the Royal Court has produced over the past 50 years. There is a great page that lists the exact dates, authors and Theatre which the play was staged in. The playwrights on that list are some of the best and most prolific in the industry:

- Carol Churchill
- Bruce Norris
- Lucy Kirkwood
- Mike Bartlett
- Mark Ravenhill
- Jez Butterworth
- Simon Stevens

These are the playwrights of our time and the people who have defined the genre over the years. As playwrights their job is to be saying the things that nobody dares touch upon. Topics that revel in controversy, difficulty and social change for the better. The voice of the oppressed, the youth and the unrepresented can be found in these plays to their benefit and to their detriment.

A lot of Theatre can be quite elitist especially if it was written in the early twentieth century. I can understand that some people reading this might recoil at the thought of dragging themselves to the Theatre or sitting down for two hours to read a play. Some people might not even want to read a book!

(If you are one of these people then you need a pep talk and you might want to reconsider being an Actor as there is a lot of reading involved)

To these people I say that the plays produced by the Royal Court strive to be relevant. Their specialty is producing contemporary pieces from the voices of unpublished or unknown playwrights. If you are looking for monologue pieces, trying to learn more about Acting or wanting to get into the craft of Acting then the Royal Court is a fantastic place to start.

Getting the book bug

When I was applying to Drama school I downloaded the list of all the writers in the past 10 years that had work commissioned by the royal court. I slowly started reading through all their plays in the library. It was a herculean task and it took the most part of 4 years of solid work in order to get through most of them.

After I got accepted to Drama school and started training I found the exercise so useful that I kept going and read these plays all through my 3 year bachelor of Arts Degree. This was an obnoxious amount of plays so I did not finish it but whilst reading through the list I discovered the playwrights that are my favourite today: Laura Wade, Moira Buffini, Enda Walsh, Jez Butterworth and the list goes on.

An exercise that would help you to no end is to read the writers that are writing for the Royal Court. You might not get through the entirety of the list - granted that I look back and think that might have been too much work - but I cannot recommend how good of a place that is to start. It is especially useful if you are looking for contemporary monologues. I will go into that specifically in choosing a Speech section but getting relevant contemporary monologues start at the Royal Court. The panel have seen the oldies a million times; if you walk in there with something they've never seen then they'll love you for it!

British Theatre: Heritage and History

I once attended a Q&A session with Simon Stevens at the Royal Welsh College of Music and Drama - where I was studying at the time. It was one of those surreal moments where a man's charisma was able to command a room to the point where you could hear a pin drop.

During the middle of the session he started talking about the British literary history. He made an extremely good point that certain countries have mediums in which their collective voice is captured most acutely. He pointed out that for the American's their medium of choice is the novel.

The Pulitzer Prize list and their incredible impact of Novelists over the past 150 years shows their prowess in this field. Steinbeck, Hemingway, Faulkner and Twain are but a few names that stand out in a long list of American authors who have contributed to this field. It isn't that they don't have outstanding writers and artists in other areas - Williams, O'Keefe, Warhol and Pollock would be very upset at that claim - but the voice of the nation is captured in the zeitgeist of the American novel.

If you were to look at the golden age of the American novel then you peer into the history of the rise of a super power. The Grapes of Wrath starts at a time when the country was starving in infancy and The Great Gatsby takes us to the glorious revels of wealth.

For the British our literary history can be captured most profoundly in our playwrights and arguably poets. Wilde, Byron, Tennyson and Milton have a completely different tone to that of the American voice.
And of course we cannot forget the quintessentially British voice of William Shakespeare of Stratford upon Thames.

Shakespeare is such a dominant figure in world culture that I would bet that there is no hour in the day where the words of the bard are not spoken somewhere on the planet.

My point is that today is no different. If you see or read the plays going on in these fringe theatres then you will notice that these playwrights are saying the things that we will be talking about in 10 years' time. This is where the big questions are being asked in Britain, and it's what we do best!

Fringe Theatres

Unless you are an extremely lucky individual or you have a relative who is a talent agent you will spend the first years of your career in Fringe venues. This is to be expected, you wouldn't want graduate doctors going straight into open heart operations and you wouldn't want people who just passed their driving test to be given an F1 car and told to take it for a spin.

Not only is the fringe scene the place where Actors take their first tentative steps but it is also the crucible for future talent. Bluntly speaking they are the places that you need to start going. It has many of the people you need to start hanging out with. Fringe Theatres are where young Directors, Designers and Creatives are experimenting and where you can see some great Theatre for reasonable prices. It is the beating heart of young artistic culture and the place you need to be if you want to enter the industry.

Remember that it is likely the future Artistic Director of the Royal Court, The National Theatre, The Old Vic and the Royal Shakespeare Company are probably producing fringe theatre shows at this point. Why don't you go out and see their shows? They will most likely be at these fringe theatres:

London:
- The Bush
- The Gate
- The Finborough
- The Orange Tree (especially good)
- Bunker

- Tricycle
- Outside of London:
- Ustinov Theatre Bath
- West Yorkshire playhouse
- Roundhouse

Scotland:
- The Traverse Theatre
- Everyman

Ireland:
- Trinity
- Abbey

Wales:
- Chapter Arts Centre
- National Theatre Wales

The larger Theatres in London and across the UK are more likely to put on established plays. If you look at the Globe's upcoming season or the Nationals it is unlikely they are going to be producing the best up-and-coming content out there. They are much more likely to be rehashing classics and attracting star talent to perform pivotal roles.

There are some exceptions when it comes to those large institutions. Young Vic Theatre, Menier Chocolate and the Garrick do some edgy productions but some of those shows are extremely expensive. Young Vic and Sonia Friedman produced Yerma recently but that was a remake of an old Spanish play that you would have had to murder someone to see.

Those established Theatres can be extremely useful if you are looking for classical speeches or want to improve your knowledge of theatre history. They can still be relevant, at times, but really they are catering to an older and more knowledgeable audience.

However, if you aren't watching contemporary theatre then your finger is not on the pulse of your industry. Those tiny fringe venues are where the radical young voices are going to come from. The voice of those playwrights are the ones that you are more likely to connect with - they are more versatile and relevant.

Once you leave Drama school and enter the real world then you will be working with a raft of other professions. Stage managers, Directors and Writers will be the contacts who can put in a good word and get you a job. If you know a hundred other Actors that isn't nearly as useful as knowing ten directors. You are going to meet those people at Fringe Theatres.

Theatre Companies

Without Theatre companies there would be no industry of new work being produced. The long standing Theatres commission work from established Director and writers but the work that you need to concern yourself with is getting to know the grassroots of the industry. Again, not to sound like a broken record, Fringe Theatre companies.
Some of the most exciting work in contemporary theatre is coming from tiny Theatre companies across the country. Some of them are not applicable to applying to Drama school: for example Volcano does a lot of physical theatre work, but some of them are names to look out for. These companies are normally the ones that headline fringe festivals such as the Camden Fringe and the Edinburgh Fringe festival.

Examples of Fringe companies

- Out-of-Joint
- Propellor
- Headlong
- Play
- Punchdrunk
- Birmingham Rep
- Frantic Assembly
- Squint

These are only the basics, if you start attending the Edinburgh Fringe festival or start going to Fringe theatres then you will get to know the other major players. There are thousands of students that create Theatre

companies every year so keeping up with the much smaller ones can become tricky.

You don't need to memorize this list or a huge number of companies but you need to start getting to know the major players in your industry. This isn't homework and it shouldn't be a chore it is something that comes naturally if you start to watch a lot of shows.

You might be asked which company you are familiar with or some of their work you have seen. In professional Auditions I have conversations about companies all the time and it is essential that you know your industry. Even if you aren't asked about this in the audition it is only going to benefit you in the long run.

Frantic Assembly

One of the most powerful pieces of Theatre I have ever seen was created by Frantic Assembly. Beautiful Burnout was a show that toured in 2010 to critical acclaim. I saw it when it came to North London when I was very young, much before I decided to become an Actor.
That show will stay with me for the rest of my life. I had no expectations when I walked through the door, I hadn't even heard of Frantic Assembly. I just went to see it with a friend and we both thought nothing of just booking a couple of tickets to a fringe venue.
The ruthless performances and the visceral choreography made a lasting impact on me. It was one of those early experiences that you cherish once you have been in this industry for a long time. My point in this chapter is to encourage you to go and actively find those experiences. This book cannot give you the experiences that you need to get into this business on its own. What it can do it guide you to the right places and people that are going to give you those references.
The Theatre is the first step, ideally the edgy fringe Theatres.

Notable other Theatre Companies
- DV8
- RSC - Founded by Peter Hall
- Sonya Friedman (she is a producer but has her own company)
- Mischief

Defining Contemporary and Classical speeches

The minimum that a school will ask you to perform is 2 speeches.

- One Contemporary
- One Classical

Some schools will have other requirements such as sight reading, songs and extra speeches. For the moment I want to tackle this issue which is at the crux of the audition process – and very important! Defining exactly:

- What on earth is a contemporary speech?
- What in God's name is a classical speech?
- What is the difference?
- Why do they insist on these two?

In order to answer these question we need a little Theatre history. This chapter will go in depth as to the two key eras that defined modern British Theatre. If you have that background knowledge then it will give you an edge into choosing better material.

The heritage of British Theatre is important to know, even if it is only a basic understanding. The effects of it are still being felt today and the institutions will expect you to have done considerable thinking when it comes to choosing your material. If that decision is an informed one then all the better!

The Golden age of British Theatre – Shakespeare

Shakespeare's theatre company were a band of outlaws that were forced to perform outside the city walls on the crime riddled South Bank of the Thames. (Where the Globe is today) The Puritans forayed Theatre within the city as well as all other activities that could be viewed as fun – heaven forbid! So anyone that wanted to start a business in the practice of bear-baiting, whoring or fighting would have to look elsewhere to set up shop. The Southbank was the place to go, a place of debauchery and vice.

Brothels, cock pits, alehouses and dreaded Theatres were built side by side. Thousands of people each day would take the ferry from the North of the river in order to spend a day in the smelly, disgusting and wonderful red light district of London.

It was likely that none of the business owners or other thespians were going to make any money whatsoever. It was a place of poverty, the plebeians had a chance to make some pennies but rarely a pound. Not many people made much money.

For some reason, that wasn't true for the company that Shakespeare was involved in. They were called *The Lord Chamberlain's Men* during the reigns of Elizabeth I and *The King's Men* when James took over the throne. They were so outstanding that they gained a royal charter from Queen Lizzie and the plays they put on are some of the best ever, even to this day. The fact that they were so successful and ended up being financially well-off is incredible.

The only reason that Shakespeare's players were allowed to build the Globe theatre and carry on their plays is because of Elizabeth I fondness of them. It is reported that the god awful play of Henry VI was written specifically because Elizabeth loved the character of Falstaff so much in the play Henry V. (same with The Merry Wives of Windsor – another God awful play!)

The plays tackled issues that were grossly inappropriate and downright criminal in the eyes of the authorities on the north of the river: murdering of Kings, adultery, sex and theft - men dressing up as women and kissing other men is still a controversial issue today never mind 500 years ago. Some may see Classical plays as trite today; the comedies may seem "jolly" and the tragedies may seem a little over-egged but do not forget that this was Theatre for the working people – and putting them on was a dangerous job. It was a cut throat world where plagiarism and sabotage was rife.

The reason why Shakespeare's plays are such an important cultural treasure even to this day was because it was the Golden age of British culture. From the dirt, grime and crime came some of the most breathtaking poetry and stagecraft the world had ever seen.
It was the time that the UK was becoming the superpower of the seas and land.

That grand-snootiness and colonial arrogance changed the status of its inhabitants but for those in the Arts it's imperative to remember that the memorable words of Shakespeare came from the gutter.

There are a lot of people who would argue that Shakespeare didn't write his plays. Of course he did co-write some plays with other playwrights but academics doubt his credentials simply because he wasn't from the landed gentry or the Aristocracy. He was well educated but he wasn't born into class.

The question is: "how can someone who wasn't born into the aristocracy write some of the best plays in modern history?" For some, this is a contradiction. They attest Byron or Marlow to the plays or they believe the bard was simply the front-man for an elaborate hoax. To me, that seems a little desperate.

For you as an Artists it is important to remember that talent isn't bestowed on the rich or the well-educated. It is innate in those who work at a craft and who have a spark. The golden age of British Theatre came about, not because of aristocracy, but because the people bought into art that was created for them. That is a theme that runs through great Artistic revolutions. Remember that above all else.

Let's fast forward to...

20th century Theatre

"Theatre is alive and now, and then it's gone" – Kevin Spacey

The 20th Century was a huge time of change in a lot of areas of our culture. The industrial revolution had called into question a lot of theories on gender equality, the working class and living conditions. Let's not forget two world wars and also the invention of Nuclear weapons but we are focusing more on the subject of culture in this book. There is a plethora of publications that go into much detail on the subject but what we are going to be focusing on is the change in British Theatre.

(Andres Marr's History of Modern Britain is a great book that tackles the macro political changes in more depth if you are interested)
What was interesting in Britain was that by the fifties there hadn't been a real change in British Theatre since the turn of the century. Stanislavski has revolutionized the process of Acting by that point but that was in Russia and that heritage didn't make its way to Britain until it was imported in from America. It seemed that, despite the unsettling events of the first fifty years of the century the old-school four act plays and music hall shows had not changed a jot.

Theatre was becoming stagnant.

It was not about the voice of the majority of people. It was about the aristocracy and was alienating to the great majority of people. It was the complete opposite of what Shakespeare and the golden age of British Theatre was trying to achieve.

Stanislavski had tried to deal with this issue by taking Chekhov's plays and using them as a conduit for his methodology. He wanted to make Acting more truthful instead of the pantomime like performances that were appearing in Victorian theatre. In a way he was successful and it was a

noble endeavour but he simply changed the mindset from an Actor's point of view – the writing was still "old fashioned."
(I'm slightly generalizing here for the sake of brevity)

Then came the momentous play "look back in Anger" by John Osborne in1956. For British Theatre this is a landmark moment and a fulcrum for what contemporary writing gave to the art form for.

You do not need to remember this year, there won't be a history test, but you do need to know that it was instrumental in changing the course of Theatre for the rest of the twentieth century.

This was not what the "landed gentry" were used to. This play revolved around a rough, loud-mouth and aggressive character named Jimmy who lived in a grimy flat and was sick of the status-quo. If you read the play then you will be faced with long visceral diatribes that contrast greatly with the poised words of Rattigan or Coward.

It was completely different from what had been seen for the past 50 years on stage and needless to say the critics didn't like it. It opened to the critics lauding it, calling it "crass" and "awful" but clearly it struck a nerve. People are still speaking about it decades later.

This was the invention of the "Kitchen Sink" drama. It was the invention of "The Angry young man." This was the beginning of contemporary theatre. From then on writers began to take on a new style of writing. It became subversive, it had its pulse on the thoughts of the younger generation and on the working population. It began to mimic the way people spoke every day on the streets. If you look at the general trajectory of Theatre there is a dramatic shift from this point onwards.

Different Drama schools have different dates that they set as contemporary speeches. RADA may think that anything beyond 1960 is modern theatre whereas Bristol Old Vic may think that it's 1963.
I would contest that the difference is not the date but the style of writing. Classical speeches are easier to pick because there are only a few writers you can choose from: they're all written in blank verse and Iambic Pentameter. Contemporary speeches are more difficult because of the confusion of when "modern" or "contemporary" Theatre actually started.

Don't worry about the dates that the author was alive and don't worry about when the play was written:

Worry about how relevant the writing is today! That is what makes it a contemporary speech!

My Mistake

I foolishly picked a Pinter monologue as one of my contemporary speeches when I was applying to Drama school for the first time. I really liked the monologue because I was obsessed with Pinter at the time but it would have been much better for me to have done a monologue from a play that I had seen at the Royal Court - a brand spanking new piece. I was too caught up in my fondness of Pinter and I wanted to talk about how much I loved his writing instead of focusing on something that I could relate to and perform well.

I'm not saying that Pinter monologues are bad for contemporary speeches I'm saying that you should pick a contemporary monologue that is exactly that contemporary!

If you have a razor sharp brand spanking new speech then you are going to come across better than if you do a Stoppard, Pinter, David Hare or a Mamet. Unless you are absolutely sure that you can nail it, then I would advise otherwise and do a brand new speech or at most 10 years old.

What makes it a contemporary speech?

The difference between a classical speech and a contemporary speech is not the issue because they are obviously worlds apart. Shakespeare, Marlowe and Webster are written in a completely different way to prose. Whether they are rhyming couples, blank verse or a combination of the two it is clear that this is not contemporary in any way. The trouble is defining when theatre became "contemporary."

We know it has something to do with the play "Don't Look Back in Anger" by Osborne but are unsure of the hard and fast rule.

My advice is to not get into a history of theatre debate and go for a piece that is no more than 20 years old max – if not brand spanking new! - And something that is relevant today. By looking for a speech that new it forces you to become more engaged with up-and-coming shows. Even if you put that to one side the judges are going to sigh a breath of relief when they realize that you aren't performing a speech they have already seen 50 times that day.

If you wish to go against my advice then that is completely fine but I have learnt the hard way that history is not something to bring into the rehearsal room! Do something that you are passionate about, not something that a teacher has told you to perform.
Lecture over.

The Do's and Don'ts of the getting of monologues

Don't

- Do not buy the plays! This is a mistake that I made and it cost me a lot of money that could have been put to better use. The only reason you are reading them is to get good monologues so buying them is not a good investment. Going on Amazon and buying a ton of books will be an inefficient use of your time and you are unlikely to find a piece that you emotionally connect to. Only buy them if you've seen it, if you know there's a good monologue in it, or if you are interested in the authors work.
- Do not buy or use monologue book!!! The amount of people who do the speeches in those books number in the hundreds. You will stand out much more if you find the speech yourself and you will connect with it better.

Do

- I would recommend going to the theatre in the day and reading through their library section, or going to a large book store like Foyle's and sitting down to read the plays. If there's a dedicated library in the theatre then ask their advice for a boy/girl monologue between the ages of 18 – 25. A lot of the people who work in Theatres are extremely knowledgeable and have seen a lot of recent plays. Their advice is invaluable when looking for monologues.

- If you don't have much time so you do not need to read the whole play. Skim through it and see if there is a speech roughly half a page long. It doesn't need to be perfect but if it is in there then take a photo and go read it aloud in the toilet or back at home. If you like it then buy it, although it is always much better to see it in a play or know the author beforehand.

The ideal situation is:

- For you to get to know an author's work. Really begin to understand their particular voice. Find a speech in one of your favorite plays learn it and then perform it with passion because you think it's a piece that should be heard.

- For you to get to know the Theatres around you. You see a play that you think is outstanding. You buy the play after you see it because there is a speech in it that you would like to learn. You learn it and perform it.

- For you to get to know a theatre company's work. You see one of their productions and you want to do a piece from that show.
This is how I find 30% of my monologues

What is probably going to happen is this:

- You skim through a play at a theatre, in Foyles or in a library and you find a monologue that is good. You read the whole play and you think "yep, I like this

- A teacher or a person in the know recommends a play and you read it. You find something good in it and you do it.

- A person at a bookshop or a friend recommends a play with a great monologue.

This is how I find the majority of my monologues

Be wary if this happens

- You pick up a monologue book and you see a speech that you think you could do well.

- You aren't sure what speech to do so you pick one at random from a play that you read.

Golden Rule

The more invested you are in the process of finding the piece then the more likely you will have success, you have to perform the speech hundreds of times so it helps if it is one that you are passionate about...

The speech will be refreshing and you will enjoy doing it more - Trust me.

Choosing a Contemporary speech

The best piece of advice I can give is for you to play to your strengths! If you did some Theatre in the past think back to a time when you really nailed a part.

If you have never done any Theatre then think back to a time when you were in front of a lot of people and you just soared!

Were you funny? Were you intense? Were you aggressive?

If you really haven't got anything to go on then think back to a time when you were with your family or friends and you told a story and they liked it.

How did you tell that story? How did you do that part?
What was it that you did that people liked?

The reason you have to think about this is because you need to identify what vibe you are selling. What is your archetype? What kind of character do you think you'll be cast as?

This is difficult because normally you are not overtly told what vibe you are giving off and it's very difficult to objectively look at yourself because that's the very definition of not being objective.

But this is a question you are going to be asked time after time after time and it is going to be the foundation of what you are going to learn when you study at Drama school. The better you answer the question of "what am I selling?" the better you will do in this industry.

A lot of the time people don't want to admit to themselves what their strengths are. Everybody wants to be the leading man or the heroine of the play. Everyone wants to be the star or the good looking maverick. However, much like Iago says "We cannot all be masters, nor all masters cannot truly be followed." In other words, you're going to have to take a long look at yourself and think what you are really putting across.

You might not be the casting of the ingénue - if you are then brilliant go with that. Statistically speaking it's very unlikely that you are. You're going to have to be honest with yourself here. What role in your day to day life do you normally play or what roles do people see you playing?

Are you the jock who plays sports?
Are you the bookish type?
Are you the enthusiastic theatre kid (more likely)?
Do you get irritated by the girls because they go after the "cooler" guys in the class?
Do you hang out with the guys more because you're a tomboy?
Are you the person that everyone wants to be around?
Are you the most popular person in your school?
Are you aggressive? Playful? Sexy?

Think about what you are and who you are because that's what you're going to have to start with.

An Actor Prepares

There is an exercise that Stanislavski advocates in his book "An Actor Prepares" which is central to his whole ethos. He asks the Actor to imagine a scenario by prepositioning it with the conditional if....
An example would be:

"How would you react if someone dropped you into a tank full of sharks?" This is a very abstract scenario but it can be used to pin down your idiosyncrasies.

"How would you react if someone tried to physically intimidate you?"
"How would you react if someone tried to kiss you?"
"How would you react if someone asked you to stand on stage and tell a joke?"
"How would you react if someone asked you jump into a freezing cold pool?"

Keep going along these lines and try to think about characters that would react similarly to you. Are you more of a cheeky Artful Dodger or a conniving Fagin? A bold and brilliant Othello or a deceitful Iago?

The problem...

There is a problem that you are going to face in this industry. In fact if you go into the arts in general this is going to haunt you from your first day until your posterity.

The problem is the balance between your craft and the commercial world. The two ends of art being a process but also a product.

In Acting the idea is for you to become a character – somebody else. Ideally this would mean that you strip yourself of your personality and you put on the skin and download the brain of another person. You could completely transform for every character and people would think you were a magician or a shapeshifter.

That is not how it works.

You cannot help but be you, because you are you. If you do a character then people will simply see you the actor doing exactly that – doing a character.

Unless you're Dustin Hoffman or Daniel Day-Lewis you can't slip 100 percent into the skin of another person and even those people don't do it 100 percent accurately.

Of course if you just walk on-stage and be yourself all the time then that is not Acting. That's the opposite problem to the one above. A lot of stars simply saunter onto stage as themselves. They can do that because they are much more focused on the commercial/celebrity side of the business. But you have to understand that you cannot eradicate your personality completely – so use it!

Personality test

Exercise:
Pick a number from 1 – 9 on each scale where you think you are:

Extroverted means you are willing to put yourself out there where as an introvert wouldn't so much
1 2 3 4 5 6 7 8 9

Intuitive person would figure things out by doing them first whereas an observer would watch others and then do it
1 2 3 4 5 6 7 8 9

When faced with a big decision do you go with your head or your heart?
1 2 3 4 5 6 7 8 9

When faced with a big decision do you prejudge an outcome or do you experiment and withhold judgement till later
1 2 3 4 5 6 7 8 9

When you are under pressure how likely are you to step up and ignore your emotions?
1 2 3 4 5 6 7 8 9

Don't worry if you couldn't answer these questions there's a website that does it for you type in 16 personalities test. This is called a Myers Briggs test and it will help give you an objective look at your personality.

I am an ENTP – A
Or a debater

When I had to do my showcase speech for my end of year at Drama School I looked at the character traits that I had as a person.

I am extroverted
I can be a bit of a nerd sometimes

I am friendly
I am sensitive

Then I looked for speeches that showed those characteristics best.
This is the key to getting a good contemporary speech and it's what a lot of contemporary actors do very well. They identify their strengths and they play to them.

You must have heard the old Socratic saying
					"Know thyself"

In Acting this is extremely important. If you want to be able to stretch yourself and play characters that are not like you then you need to start by knowing exactly what you are first.

Introduction to Shakespeare and the classical speeches

To open this section I would like to share an extract from the Guardian on the subject of the use of voice in Theatre:

"Leading figures in theatre have hit out at "mumbling" actors who imitate Americans and are only comfortable playing characters like themselves. Edward Kemp, artistic director of the Royal Academy of Dramatic Art, and actress Imogen Stubbs warned that an increasing number of young actors were unable to deliver their lines properly.

Stubbs, 52, cited Baz Lurhmamn's The Great Gatsby, starring Leonardo DiCaprio and Carey Mulligan, and said: "You're just longing for it to stop and breathe. I thought the actors looked embarrassed. They were rather garbling their lines."

"The naturalistic, mumbling acting style tends to go with people who are playing something closer to their obvious self."

Mr. Kemp said he feared the problem could wipe out audience interest in "plays of language" — including works by Shakespeare, Wilde, Coward and Pinter. He said RADA has even had to scrap its long-standing sight reading test of Charles Dickens because it was "so painful" to hear. It has introduced grammar lessons and is rethinking its voice training."

There are a couple of things to take away from this:

First, you should take this with a pinch of salt. This was an obvious publicity stunt by RADA as what followed the article was a plug for a festival they were launching. What better way to draw readers in than to criticize Leonardo DiCaprio? So I do not recommend you walk in there and chew through your lines to show that you can speak properly!

However, the second thing to think about is that a very well renowned Drama school has made the comment that young actors who mimic the style of film actors (they said "American" but this is clearly a style that's more suited to film) do not fare well when it comes to handling difficult language.

A drama school is not going to expect you to be a perfect speaker of classical writing.

> *But you need to pay attention to this as this is an important and valid point!*

Make sure you show the schools that you are able to engage with difficult mediums of writing and Acting. If you do not show enthusiasm for this aspect of the audition then they will note that it will affect how you will be able to connect with the training.

Type in to YouTube:

> *"Old Vic in conversation with Mark Rylance"*

Mark Rylance was the Artistic Director of the Globe theatre from 1997 – 2007. If there is anyone alive who knows more about speaking and acting Shakespeare than Mark Rylance then he is probably playing Gandalf in The Lord of The Rings or she is so famous that a ticket to see her would be £100 minimum.

Don't worry so much about what he says but rather see how passionate this man is about his craft.

Here are a couple of extracts of what he says:

> *"Talking about something you're going to do without actually playing it… can build up a big expectation of how it must be."*

> *"Playing and being spontaneous is a more fruitful way of knowing what to do"*

What is he saying?

Planning and talking about what you're going to do before you do it can mean that you're nervous about getting it wrong.

Not being judgmental and just having a muck around is a better way of finding what to do.

He is positive and has an enthusiasm for the craft of speaking classical writing. He is talking about having an open mind when reading Shakespeare and not judging about how it should be performed.

This is the kind of mindset you need to employ when tackling Classical text and when you walk into the audition room.

Non-judgemental Attitude towards Shakespeare

What they are looking for in a Shakespeare classical speech is to see if you can connect with the words despite it being in a different style and of a different time. The words are archaic and nobody speaks like that - not even people at the time spoke in that way.

They give you this difficult task because some contemporary actors have a particular niche or are typecast and have a reputation of being a one trick pony. Imogen Stubbs pointed out that actors on film and television often "playing something often close to their obvious self" that is much harder to do in a classical play.

Shakespeare's words and plays are so universal and visceral that you have to step out of your own comforts and tricks and give yourself to the words.

That sound a bit new-agey but stay with me.

Contemporary writing is the opposite. You see a lot of modern actors and they paint a lot of their own personality onto the words. Look at Doctor

Who, look at actors like Marlon Brando, Robert De Niro, Nicholas Cage, and Johnny Depp: they take the text and they make it their own.

They add pauses they have certain faces or energies that they like to return to. This is not bad at all it's just a style that has emerged out of screen acting. That's why they're worshipped as celebrities because their personalities are simply slotted into a very glamorous story-line. The line between reality and fantasy is very thin.

Exercise:

Type in "The famous restaurant scene from Heat" on You Tube. What do you see?

Robert DeNiro does Robert DeNiro and Al Pacino does Al Pacino. Ever heard the saying:

"Be yourself: everybody else is already taken" - Oscar Wilde.
This works fantastically well on TV and even better on film.

These two are just brilliant. They know exactly what they are and they just DO IT! They're master screen actors and always were from the start.
If you want a bit of fun then type in "Robert De Niro loses his shit!" on You Tube

This is a piss take but it is making light of a serious point. Robert DeNiro just plays Robert DeNiro. Which leads me onto the crux of the conversation...

You cannot do this with Shakespeare!

"You cannot bring Shakespeare down to your level you must raise yourself to his"

There is a quote from when Dustin Hoffman played Shylock with Peter Hall:

"You can't improvise this shit!"

If you read the book The Empty Space Peter Hall describes how Dustin Hoffman dedicated swathes of his rehearsal time to living the character of Shylock. Dustin Hoffman wanted to get connected with the character using the Method Acting approach. He found that he had no problem moving like the character, thinking like the character but as soon as he tried to speak like the character... He found out the hard way that he had to go the opposite route.

"You can't improvise this shit!"

At first...
It's going to feel fake
It's going to feel a bit strange.
You might not like it.
You might think "I don't even want to do Shakespeare I just want to do TV and film"

You've got to do this to get into drama school and if you really look more into this you will understand that you might need to do this to become a great actor!

Books to read

If you like to read then skip straight to the list. Well done you are a good human being.

If you don't like reading then you might need a little tough love at this point. I'm sorry to be the one to say this: if you don't like to read then you are in the wrong profession. That might sound a little blunt but it is true. You will have to read hundreds of plays, you will have to read your lines hundreds of times and you will need to be able to sight read extremely well.

If you don't like to read then start forcing yourself to read. It is absolutely essential that you figure out a way to consume a huge amount of literature whether you like it or not. Once you've figured out a way to do that then read these books if you find them interesting:

Drama Theory

- Shakespeare on Toast – Ben Crystal
- The Empty Space – Peter Brook
- Three Uses of the Knife – David Mamet
- True and False – David Mamet
- The Actor and the Target - DeclanDonnellan
- Constantin Stanislavski – an Actor Prepares
- In-depth Acting - Dee Canon

Further reading

- Impro – Keith Johnston
- Impro for storytellers – Keith Johnston
- Uta Hagen – Respect for Acting
- Patsy Rodenburg - Presence
- The Excellent Audition Guide - Andy Johnson

These titles are the best of the bunch when it comes to reading material for Acting. Trust me, I have read them all and books on Acting can be hit and miss. They are either written by people who have never acted anything in their life or they are written by teachers who take themselves far too seriously. I won't go into specifics - just take my word for it these are good.

Plays

These recommendations are only meant for those who need a fundamental knowledge of Theatre history. It's meant to serve as a touchstone for those who want a basic understanding of the best plays and playwrights.

This could be a whole bible of plays and could take you years if I go on so all I'm going to do is give you a choice of two for each category and you choose which one you think sounds best.

For the Shakespeare and the classics you can watch a lot of these online for free. There are some great BBC versions and the RSC has recorded a couple as well. They may be a little dated but it means that you will get the story line better than by reading it.

Shakespeare

- 1 Shakespeare comedy to Read:
 - Measure for Measure
 - Midsummer Night's Dream
 - Winter's Tale, The Tempest
- 1 Shakespeare Romance to Read
 - Winter's Tale, The Tempest
- 1 Shakespeare History to Read:
 - Richard III
 - Henry V
 - Richard II
- 1 Shakespeare Tragedy to Read: You should really know –
 - Romeo and Juliet, Hamlet, Othello, Macbeth (King Lear if you're feeling brave)

Classics

Choose one of each if there's only one option then that is the notable work you should know

- Ben Webster: Duchess of Malfi
- Ibsen: Enemy of the People, Dolls House
- Chekhov: Three Sisters, Uncle Vanya
- David Mamet: watch Glengarry Glen Ross, read Oleanna
- Tennessee Williams: A Streetcar Named Desire
- Arthur Miller: The Crucible, Death of a Salesman
- Bertolt Brecht: Caucasian Chalk Circle, Mother Courage and her Children
- Noel Coward: Hay Fever and watch interview on YouTube
- Edward Bond: Saved
- John Osborne: Look Back in Anger
- Pinter: Old Times, The Caretaker

Modern

- Mark Ravenhill: Shopping and Fucking, Some Explicit Polaroids
- Jez Butterworth: Mojo, Jerusalem, Ferryman
- Caryl Churchill: Top Girls, Cloud Nine
- Simon Stephens: Motortown, Punk Rock

Further Reading

- Ben Elton
- David Hare
- Sarah Kane
- Tom Stoppard
- Alan Ayckbourn
- Alan Bennett
- J.B. Priestley if you're feeling socialist
- Rattigan if you're feeling conservative

Choosing a character

This website is going to be your best friend for finding a Shakespeare speech:

http://www.shakespeare-monologues.org/home

I do not expect you to read the entirety of Shakespeare's cannon. I doubt you will read half the books on that list but I do not doubt that you will have to read through a list of monologues to see which one you like. This website is fantastic.

You click on whether you are a man or a woman and it gives you all the plays and all the possible monologues within them.

The Tragedies
The Comedies
The Histories

There is no short cutting this bit. You should read through a handful of speeches from each genre and pick which one you think you could do best. What I recommend is that if you find a speech you like you read the scene that the monologue is from and figure out the circumstances of the character.

Let's take an example:

I go online to shakespeares-monologues.org and click on WOMEN
I click on the play Henry VI part I
I see that there is only one female character that has speeches and that is Joan.
I see that the first speech she has is an absolute cracker:
"Look on thy country, look on fertile France,
And see the cities and the towns defaced
By wasting ruin of the cruel foe..."

I read the speech and I get the gist that France is not in a good way and that the main cause of the unrest is the English king Henry. Hypothetically I think I could play that very well.

What I would do then is read the scene which is Act III Scene III and find out the circumstances in which she's saying the speech.

Who is she talking to?
Where are they?
What is she trying to persuade the other person to do?
Is her language aggressive?
Is she trying to be sweet and caring to the other person?

These are the things you need to think about in a speech.

I will go into this in more detail in the section about "Preparing a speech" but whilst reading the speech try and imagine the situation that the character is in.

Which one to Choose?

Going back to my advice with choosing a contemporary monologue. Choose a speech that you think you can do well. I do not you're your personally so I cannot give you any advice apart from pick a speech that: inspires you; scares you or compels you! I can't give you any exercises for this you simply have to read through as many as you can and make a judgement call.

The main thing is to use this website to survey the different options you have. However, after a couple of days looking you have all the necessary information and at that point you simply need to choose one and stick with it!

Do not!

- Do not choose a nymph or fairy character. If you walk in there and start skipping about as you say the speech you might be showing your movement skills but they can tell nothing about your acting.

- Props: It's absolutely fine to bring in a piece of blank paper if needs be or a handkerchief but if you're thinking about bringing in a teddy bear (I've seen this) or a plastic knife (I've also seen this) then just don't. Let the acting do the work and when you have a prop they're more than likely just going to be distracted.

- Do not! Take everything I say as hard and fast rules. If you read Othello and you think you could do the speech "It is the cause, it is the cause my soul" then do not let me tell you otherwise. These are only guidelines but you're the one who has to go in there. It is more important that you are passionate and confident about what you are doing. Enjoying it is more important than getting it right!

Don't:
- Do not choose a character who is much older or younger than you. They will infer a lot from you by the choice of speech you make so be brave and try to cast yourself in a part that you think you could nail! However, this doesn't apply to every character. For example a 20 year old girl could do Lady Anne from Richard III. Granted she is a much older character but the part offers a lot of emotional range and the monologues are beautifully written.

What I'm saying is that the same girl should think twice about playing the part of the maid from Romeo and Juliet. This part has no three dimensional range in her emotions.

Sometimes Shakespeare simply writes in older characters because they're comedic.

Polonius does not have very much emotional range that a 20 year old guy can access. It's not his age that is the problem it's the fact that his speech isn't very emotionally charged.

Ideally you want a role that you could be cast in whose emotions are easy to access.

What to do once the right speech comes along

If you decide to do a speech then you undoubtedly have to read the entire play that that speech is from. If you are feeling extremely lazy then you can read the synopsis on a website however don't be surprised if you don't get a call back.

Read the scene that your speech is in at least 3 times because that is what gives you some vital information about the given circumstances that the character is in.

People get tripped up on this all the time in auditions. They turn up with only the lines in their head and when they are asked by the panel about the characters intentions it's obvious they have no idea what they are talking about.

Don't be one of those people that deliver a good audition but are then rejected because the panel discover that you are lazy!

Don't cut corners and read the play you're doing your speeches from – I cannot emphasize this enough.

The Basics of performing Shakespeare

Once you've chosen a speech you don't want to learn your lines just by looking at them in your bedroom. It's better to say them in different ways so many times that you just naturally remember them.

The problem with sitting down and trying to memorize them is that they come out boring because the process of learning them has been invariably boring.

In this section I will talk very briefly about how to tackle Iambic Pentameter in text and then go onto basic exercises to prepare a speech.

Exercise:
Have your Shakespeare speech written out or typed up on a piece of paper.

It should be in blank verse which means there is a capital letter at the start of each line.

Let's take an example from a line written by Shakespeare:

"If music be the food of love play on"

Notice how there is a rhythm that alternates back and forth throughout the line:

If MU - sic BE the FOOD of LOVE play ON

Every second syllable there is an emphasis in this line. We do this all the time in everyday speech and its part of the way the English language is structured.

This doesn't need to be on the second syllable every time this one just happens to have 10 syllables — which is called iambic pentameter.
You don't need to know about this perfectly or in a lot of depth — do this exercise and you should be on your way.

All I want you to do is read through your speech and tap out the rhythm behind the words. When you think there is an emphasized beat then I want you to step forward on your dominant foot and then rock back on your other foot for the de-stressed words.

You'll look like a bit of a muppet because if anyone saw you you'd look like you were dancing with a piece of paper in your hand but it's important for you to feel the rhythm in the writing and not just speak it plainly.

Do not make the mistake I made of going into the audition and trying to show the panel that I knew what the rhythm was. Once you think you feel

the rhythm then drop it! Speak the speech normally as if you are saying it. The rhythm is just meant to inform your choices and not to constrain you. Alternatively you can tap this out with your hand on your thigh:

"To BE or NOT to BE that IS the QUES-tion"

"tap TAP tap TAP tap TAP tap TAP tap TAP tap"

This line has 11 syllables which is called a feminine ending, and when you go to Drama school you'll learn that there are many more technicalities in Iambic pentameter. However, you don't need to know the names of them in order to find what the rhythm is.

You speak this naturally if you just say the line, so don't think about it too much.

Become aware that there is a rhythm in the language but don't overly focus on it or think that you have to demonstrate that when in the audition.

> *When you read books on Shakespeare they get extremely technical very quickly.*

If you are an actor you should focus more on feeling and not on thinking but this rule is good to know.

Golden Rule

> They aren't looking for perfection and they know that you have very limited knowledge of Classical text. So don't think you need to show that you understand Iambic Pentameter. Focus on the truth of what the character is saying.

Translating Shakespeare

This isn't so much an exercise but a way of translating some of the syntax and words from an older vernacular of English into one that you understand.

Even experienced Actors cannot pick up a piece of Shakespeare and instantly understand the meaning of every sentence. Some of the words are not used in modern English, some words do not share the same meaning and some of the syntax is archaic.

A classic example is the use of: "Thou", "Thee" and "Thine"

This comes from the influence of the mainland European languages such as German or French that have further differentiations in the way they address individuals. In Shakespeare's time this system was used in tandem with "He" "She" and "They." You can see how this would be useful because of the specificity that added.

However, in modern English we do not use this.

The way to "decode" Shakespeare

The ideal if for you to type every word that you do not understand into an online dictionary and expand your vocabulary so that you can make sense of the sentence.

Most of the issue with understanding Shakespeare is that he had an enormous vocabulary which we no longer have an understanding of. His use of words are borrowed from academic, anthropological, botanic, legal, medical, mythical, biblical, mechanical, classical, ancient and many more areas because he needed a vast array of metaphors to make his characters come to life.

However, you don't need to trawl through a dictionary today in order to find the meaning of these words. You simply type them into a search engine or an online dictionary.

Let's take an example from the character of Cassius in the play Julius Caesar:

"Why, man, he doth bestride the narrow world
Like a Colossus, and we petty men
Walk under his huge legs and peep about
To find ourselves dishonourable graves."

Cassius is talking about Caesar to Brutus but what is he saying about him?

"He doth bestride the narrow world"

He does dominate the small world

"Like a Colossus"

Like a giant

"and we petty men"

And we insignificant men

"Walk under his huge legs and peep about"

Are beneath him and look around

"To find ourselves dishonourable graves"

To find that we end up dying dishonourably

This is just an example, but you need to do this with every line of text in Shakespeare. You have to understand what he is trying to say and then "translate" it into your own words. I guarantee that this is what the

teachers will ask you to do at Drama School and that professionals do this as well.

How to prepare a speech

"Practise makes perfect!"

This chapter is going to be venturing into a technical area that many books make overly complicated. I always think that those people who make Acting difficult with technical jargon are getting in the way of themselves. When you are acting it should be second nature and come freely. Everything you do, whether it be learning lines or research, should contribute to a natural performance and not one laboured with complex technique.

A lot of this is going to be taken from what I learnt whilst acting professionally with brilliant Directors and what I learnt whilst at Drama school. Many people learn the lines of their script and assume that they will figure out the intentions and meaning of lines whilst they are saying them. This is a mistake, you don't have to have everything figured out beforehand but you must have a process to unpick the intentions behind the lines.

Learning how to break down a script and prepare monologues is one of the foundations of professional Actor. The two sections on the subjects covered in this chapter will be:

- Units and Objectives
- Given Circumstances

There are many more ways that you could approach a script and tackle text but these are the broadest and easiest to digest. Depending on where you train and who you work with you might have more specific methods but you will be hard pressed to find a quality teacher who does not swear by these two tenants.

Units and Objectives

When an actor picks up a script then they cannot just read through the lines once and then act them perfectly. I would argue that even if they read the lines one hundred times they wouldn't be able to act them effectively at all.

There is a method of picking apart a script so that you understand it better which is called Units and Objectives.

Think of it like this...

If you were going to learn how to sing a song you couldn't just listen through it once and then instantly repeat it – unless you had been singing for decades. Even if you listened to the song fifty times you would know the start much better than the end because we remember things in a linear fashion - start to finish.

If you were smart or if you had a decent teacher then you would tackle the song in sections. You would first learn the verse and then you would move onto the bridge and finally the chorus. By doing this you can tackle the song in much more manageable sections.

When you find a monologue you need to break it up into smaller chunks in much the same way. You learn the verse, the bridge and then the chorus. Once all of the sections are learnt then you can practice stitching them all together.

These sections in Acting are called units.

If you were to go by gut instinct then you might learn a speech a sentence at a time or a line at a time. This is how I started when I was acting as a child. The problem I found was that often the lines would come out very similar. Sometimes they wouldn't make sense because I had learned it in a particular way and had been speaking it in a certain rhythm. The reason

that learning lines using units is important is because the intention is linked to how you learn your lines.

If you just learn words then they have no meaning and no imagination behind them. You have to learn them in a way that brings them to life which is by linking units to objectives.

What is a unit?

The way that you know a unit has begun or finished is if the intention of the character has changed. A lot of people would argue that a unit is a change of subject but that would severely limit the amount of changes within a scene. A subject may stay constant throughout a scene but it wouldn't be entertaining at all unless there were changes in the Character's intentions.

Imagine that you were trying to persuade one of your parents to let you go for a night out despite the fact that last time you didn't have enough money and they had to pick you up at 3 in the morning.
You have prepared a list of reasons as to why they should let you go out and give you some money. Those reasons are not all going to be along the same lines and you might change the subject in order to get some emotional leverage.

- You might say "It will mean you won't have to cook me dinner"

- You might try to guilt trip them "you don't want me to have any fun"

- You might say "but my siblings got to go out when they were my age"

- Then you might try to flatter them "you guys are normally such cool parents"

- Then throw another logical reason back in there for good luck "This time is different, I saved up for the night"

The changes between these points will be classed as different units - the unit changes when a different tactic is applied. If there was a different subject that was raised then you could also class that as a different unit but what is more important to remember is that subject change is in itself a tactic.

What is an Objective?

The unit is a classification of when a tactic is applied during a scene. The objective is the classification of which tactic that is.
For example if we were having an argument a unit change will be when someone changes tactic. We might be trying to hurt each other verbally but I suddenly change my tac. I could start to try to make you jealous. That change in unit is "actioned" with jealousy until there is another change or someone changes the subject.

Actioning

There is a great book called "Actioning: The Actors Thesaurus" which list different words that can be applied to tactics. These are great if you want to get specific as to the nature of a tactic.

Going back to the example I gave before, in the argument scenario, the word jealousy might be too generic for the way you play that unit. You might want to find a word that is more insidious, vicious or cruel.
The point is that an objective is a way for you to play a unit. It gives you something to aim towards and helps you let go when acting. The trick is to carefully research and plan which tactic you think your character should go for. However, when you rehearse and when you Act you should one hundred percent go for it!

Breaking down the script

So, you know what a unit is and you know what an objective is but what exactly do you do with the script?

This is such a personal topic and what an Actor writes on their script is not something I'm prepared to prescribe. All I'm willing to do is say what I have found optimal.

As you get more experienced you start to spot patterns about how you work and what sticks in your mind. I have picked up other Actors scripts only to find a hurricane of scribbles paired with some fantastically focused work. Other times there are Actors who spend so long making their script and folder immaculate that they forget they can't take them on stage! I learnt my current method from a wonderful director whom I won't name as he is no doubt going to be a big name in Theatre in the future. It is a very simple method but one that you can tweak and make your own to your hearts content.

List of Acting Exercises

Exercise 1:

Have your speech typed up or written on a piece of paper.
Have two stations where you can sit: for example set up a chair and your bed (this will make sense in a moment)

Say the first sentence of the speech whilst sitting down in the first chair. Then before you say the next sentence switch to the other chair and speak the second sentence.

Carry on switching for every sentence until you get to the end of the speech.

This will help you identify the moments that the characters change their thoughts and will help you plot the tempo of the speech.

The problem with a lot of people who audition is that they start the speech and then just rush straight through it without any breath. Think about those moments when there is a full stop: what are those characters thinking? Whatever they would be thinking is exactly what you should think before you open your mouth to say the next sentence.

Enjoy those moments between thoughts because those are the moments that the magic happens!

Exercise 2:

You can do this in a park or a spare room because you'll need a little space.

Start walking in a straight line as you speak your first sentence.
When you reach a full stop then stop completely turn in a different direction and speak the second sentence.

Carry on until the speech is finished.

This is a better speech for involving your whole body because you are standing up.

When you are speaking those lines I don't want you to act it I want you to really think about the meaning of what you are saying.

Don't worry on looking good or being persuasive worry about whether you understand what you're saying.

If you are saying a speech and thinking about how persuasive you sound or what actions to do then you're focusing on the wrong thing.

Try and think about the words you're speaking and work on getting clarity and understanding of your speech.

Exercise 3:

A great way that I learn my lines is to record myself whilst I'm doing these exercises.

I then listen back to the audio recording.

Just listening to the different way you do the lines is a great way of knowing what you're getting right and wrong. There will be moments that you can hear that you are understanding what you're saying and you know exactly why you're saying it. In contrast, there will be other moments that you can hear that your understanding of the words are a little hazy and grey.

Listen to those tracks multiple times and listen to those moments, try to pick them out and remember the way you approached those thoughts. Alternatively you can film yourself whilst you do these exercises but I think that I can always tell by the sound of it whether I'm connecting well with it.

Given Circumstances

You have to do some research into the circumstances that the character is in whilst you are speaking the lines. Knowledge of the lines and how they are structured are completely useless unless you know the context in which they are being said.

These are called the Given Circumstances

You need to answer these questions for both your contemporary and classical speeches.

Who am I talking to?
What am I trying to do to them?
Where am I?
Where have I just come from?
Where do I want to go?

In answering these questions you will undoubtedly discover facts that will inform the way you deliver the speech. It makes a big difference if your character is breaking up with their partner after murdering someone than if they just ate a bowl of cornflakes.

An example:

When I was applying for Drama School I learnt a speech from Henry IV part I. I enacted my own advice and I realized that the place that Hal would have been speaking the speech would have been in Windsor castle. Whenever I performed the speech I would imagine that I was standing in the great hall in Windsor castle.

And whenever I performed the speech I would imagine that my father (The King) was standing in front of me.

I love performing this speech even to this day because I have put in the work to flesh out the lines with my imagination. It goes back to what I said at the very start of this book: "The more effort you put into learning a speech the more you will enjoy it!"

Performing the speech

When you get to know the lines better and when you've gone through the given circumstances then practice the speech in full Character. It's going to be difficult because 99 percent of the time you will be speaking to a wall in an empty room. What I want you to do is remember the circumstances that your character is in: Where are they? Who are they speaking to? Where have they just come from? What are they trying to get from the other person?

Then really try to imagine that other person on that wall or wherever you are rehearsing the speech.

The more research you do about the circumstances the easier this will be. Every time you do that speech keep that imagination going!
Don't just say the lines for the sake of saying them, really think about why you are saying those words.

Anyone can get up and say words only an actor can get up and bring life to those words

If there is one thing you need to work on it is being able to allow yourself to be in the situation your character is in.

Don't worry about getting the rhythm right when you are in that room – you're not an expert on Shakespeare and they're not expecting you to get that perfect.

Don't worry about pronouncing the big words right or doing big Shakespearean hand gestures.

To be a good actor is to transport yourself into another set of circumstances and from there play!

Trust yourself – that's the only person you've got.

Choosing a song

"If Music be the food of love play on" – the Bard

You are not reading this book to become a singer. Of course there are wonderful Actors who can sing but Drama school training will see singing as a secondary priority. If you want to work in Musical Theatre then I recommend that you focus more on the technical aspects of performance and apply for that course. If you want to be a singer songwriter then go buy a beanie and some guitar lessons. You are reading this because you want to be an actor so your criteria is different.

The focus for a Drama School panel is not to see if you can sing but to see if you can act through a different medium – same thing with Shakespeare. There is a big difference between a singer who performs a song and an Actor who performs the same piece. They are trained to focus on different areas of performance which will affect the end result.

When you train as an Actor you are exposed to a number of different mediums: Radio, Screen, TIE, Improv ect. Half the criteria for success is how you deal with being pushed outside your comfort zone. On a typical day you will walk out of a screen acting class you will then walk down the hallway and immerse yourself in a movement class. The two different classes are completely different disciplines so you will not be comfortable Acting in certain circumstances.

You have to be willing to jump in head first, meanwhile manage your emotions. So if you consider yourself a "bad" singer then change your reticence to enthusiasm – it's going to happen so you might as well enjoy it!

For those of you reading this who are fantastic singers think about what scenarios that might make you feel vulnerable. If you are asked to dance or sight read and you aren't as confident in that discipline then you must manufacture the same enthusiasm that those non-singers muster during

auditions. This advice is really important because it is something that you must bring into everything you do in the arts.

Good singers

Now, some people can sing extremely well. If you fall into this category then you want to show your technical skill as well as your ability to act. A lot of the time Musical casting directors will choose actors instead of Musical Theatre graduates because their style of performance may be better suited to the piece – so if you have this string to your bow then use it!

These are suggestions that you can either borrow directly from or use as inspiration for choices.

I would recommend that you use any suggestions as starting points and then explore further from there.

Modern Musicals

- Up tempo

Shreck, 5 Years, Once, Mamma Mia, Lion King, In the Heights, West Side Story, We Will Rock you, Book of Mormon – these all contain good standard choices.
Anything along these lines will be a good choice. If it's in the west end at the moment and it's a light cheery song then you cannot go wrong!
- Ballad

Ballads are a little more difficult. People are much more prone to enjoy up tempo songs even if you're not technically gifted. Ballads, on the other hand, can be excruciating if you haven't got the good to back it up. Tread carefully!
Sondheim post 1980 - Into the Woods, Company, Merrily we Roll Along. Be careful of picking Phantom of the Opera. Everyone does it, so I wouldn't recommend it unless you can properly nail it.

Be careful of picking Les Miserables for the same reason. I did audition with a song from Les Miserables but it's because I can sing and I would be castable as the part in the show.

Parade
Blood Brothers
Rent
West Side Story

Classic Musicals (pre 1980)

These are a more interesting choice. These songs usually I would recommend you start with the links I've given you and then search the suggestions that YouTube give you and see what you like.

· Up tempo
Search songs by Cole Porter (Anything Goes), Rodgers and Hammerstein, (type in BBC proms 2010 where they did a Rodgers and Hammerstein concert), Sondheim wrote some great musicals pre 1980 – Follies has a wonderful comic song in it called "God-why-don't-you-love", Merrily We Roll Along. Lloyd Webber did some musicals which would be classed as classic today such as: Evita and Cats.

· Ballad
Gershwin (summertime)
Richard Rodgers and Lorenz Hart's "My Funny Valentine"
Lloyd Webber has some ballads in Cats and Evita.
Oklahoma by R&H has some great ballads as well as their other works
Jazz/blues Standards

To search for these songs and get a general gist I would search the great artists of this generation and pick a song that you think you could do extremely well. I've put songs next to their names just so you can have a starting point. I would carry on searching until you find something that you like.

Women:

Etta James – At Last
Nina Simone – I put a spell on you, Feeling Good

Ella Fitzgerald – Cry me a river
Peggy Lee – Fever

Men:

Ray Charles – Georgia, Hit the Road Jack
Nat King Cole – Unforgettable,
Frank Sinatra – (be careful because people do his songs a lot) That's life
Louis Armstrong & Bing Crosby – wonderful wonder, as time goes on.
You don't need to sing it like the artist themselves. But get an idea of what notes to sing by listening to it a lot and pay extra attention to the vocal expression these people use. They have bucket loads of soul, think about what you can convey when you sing.

If you like this genre then check out the songs of

- Cole Porter
- Gershwin
- Duke Ellington

Rock/Pop songs

Same as Jazz and Blues I would look up artists that you particularly resonate with. Modern artists might be Amy Winehouse, Jamie Cullum, Cobain, Johnson ect...

Be careful with contemporary songs, a lot of schools don't like it because they don't offer any emotional range. The song has to have some sort of journey in it, if it's bland then chuck it! Doesn't matter if it sounds nice, always put the acting before the song choice!

Unaccompanied folk or light jazz song

If you are from Ireland, Scotland, Wales or are from a foreign country then it would be an extremely intelligent idea to research a song that is an old folk or traditional song. Not only will you connect better with this but they might ask about the song which will give you an opportunity to talk about yourself.

The people who pick these are very intelligent and I would strongly recommend you using any cultural heritage you have to your advantage!

Bad singers

If you do not sing well then I would return to the advice I gave about choosing a monologue. Play to your strengths!

Check out Rex Harrison in My Fair Lady - type in:

> *"Why can't a woman be like a man?!"*

Into the search bar of YouTube.

That man cannot sing a note but he endows his words with personality and does a half-speak half-sing technique which masks his inadequacy at singing. He gives a fantastic performance, arguably one of the best in Musical history (from a bloke).

Don't
- This is just a warning to those who may want to choose a rap song. I think if the track in question tasteful the panel may actually like it. I wouldn't pick a section that has huge amounts of profanity and I would try to include some sung notes. Just so you know this is a risky choice and it's a much safer bet to go with one of the many suggestions I have suggested above. However, if you think you can pull it off and if you know you'll own it 100% then I would suggest to do it. Much better to do something you enjoy than something you feel you have to do.

- Don't pick a club or house music track this should go without saying but some people mistake their liking a track to its suitability. Trance or anything that has a repetitive quality. To act through music you need texture and lyrics with emotion to connect with. Club music is designed to be monotonous and repetitive – the opposite of what you want.

- Be careful about picking contemporary songs. They have to have emotional depth or they have to have some sort of character

development! There are a plethora of suitable songs by some fantastic songwriters so I would recommend staying away from the latest pop sensation.

Conclusions

Singing in an audition for Drama School is like performing a speech by Shakespeare: they will be delighted if you have the technical stuff down but they will be able to see talent even if you don't. Remember they have done this thousands of times. Each day they see hundreds of auditions and they are very good at spotting talent – that's their job.
The one thing you can do to make it more difficult is being nervous about singing or doing something outside your comfort zone. Try not to, try to enjoy it, even if you're crap and you will do all the better for it!

Choosing a school

"Acting is a very personal process, it has to do with expressing your own personality" – Ian McKellan

Choosing a school is like choosing an agent or choosing a partner, it is extremely personal and will come down to your gut instincts.

Advantages to Training in London

The agents are very close. Some of the best agents in the Industry will be a tube ride away. They will watch all of your performances and they will attend your showcase. If you go to a London drama school then you have better exposure – no doubt about it.

All the best Theatre is in London. The standard of Theatre in London is world class and a lot of the students at Drama schools get cut price tickets. When I was studying in London I went to the Theatre sometimes 4 nights a week and I loved it!

Disadvantages to Training in London

It is incredibly expensive living in London.

This has an impact on the type of social life you will experience. People won't be going out as much and your social circle will be quite insular unless you make an effort to make friends outside of the course.

Depending on how much money you have access to it might have an impact on how much you enjoy your experience at the school. If you're going to be constantly worrying about paying rent or whether you can afford to eat (something which happens surprisingly often) then it might be something worth thinking about.

I know a lot of people who cannot enjoy an active social life simply because of the monetary requirements of living in London. The schools are absolutely fantastic but if you are a social person who likes having a varied life then you might want to think twice about going to a London drama school.

I trained for a time outside of London and I had a fantastic social life because of the amount of disposable income I had. I wasn't rich by any standard but the ability to have a night out with friends is invaluable in a tough place like Drama School.

Advantages to having a "name" behind you

A place like RADA or LAMDA is a big thumbs up on your CV. No one looks at those names and doubts their credentials. It is very helpful to have a name like that behind you.

It is unlikely that you will get cast in anything simply because you trained at a big name but anyone who thinks it doesn't help your chances is kidding themselves.

However, I will not lie that the pros of a big "name" run out very fast unless you really want to train at that institution. I would not place much emphasis on this and put a lot more value on your gut feeling of whether or not you want to spend 3 years at that place.

Disadvantages to going to an old Institution

There are some criticisms of big name drama schools that they are out of touch with the rapidly changing world of Acting and I think there is some truth to that.

The introduction of Netflix and Amazon; the rising popularity of Self-taping and the pressures of "big names" to sell tickets are something that are changing the game.

I wouldn't say that you were at a disadvantage from training at a huge Drama school but I wouldn't say that you were at an enormous advantage from people who didn't train in London either. The courses have been taught the same way for decades at a time and some people in the industry criticize that you can tell an actor comes from a big institution simply by looking at them on stage.

Of course having a big name is nice to have on a CV but you should always put your personal development before the prestige of an institution – that is the main point.

If you are the sort of person that would thrive at a place like RADA, LAMDA or Central then I would wholeheartedly encourage you to go for it.

If you are someone who does not agree with prescribed mentalities and old school structure to art then I wouldn't recommend it.

Conclusions

Acting is a tricky game.

There are always going to be fashions of the time.
Sometimes the public school boys of Eton and Harrow will be cast in everything then the rough and tough bad boys will be the stars.

Sometimes a child actor will flourish into a fully-fledged legend and sometimes they would have trained at a high fallouting institution. Drama schools are the same...

They rise and they fall they sometimes produce gold and sometimes awful garbage.

The only constant that you can control is your own personal development. My advice would be to go for the school that you think will support you best. Whether that's a school that will push you hard and expect a lot from you or one that may be more nurturing and relaxed. Don't go for a school simply for its reputation or what other people have said about it because their opinion is invariably biased.

For every school go on their website and do your research before but the main bulk of your information will come from your actual audition. Does the school feel welcoming?

Are the students showing you round kind and attentive?
Are the students happy to be in the place they are?
What is the general vibe of the place?

Some of the auditions I went to for Drama school were absolutely horrific experiences. I won't name names but some of the bigger schools felt like a meat market. The panel were curt and sometimes outright hostile.
Only go to a school if you get a good impression from it – if you feel like you will enjoy it and learn a lot from your time there.

Other people's opinions and the reputation of a school mean nothing because no one actually knows what they're talking about in this industry when it comes to training. It's too complicated and too chaotic for anyone to give you a hard and fast rule. The only constant is your own preference. If you didn't like the feel of the place and the rejected you then see it as a sign that it wasn't meant to be.

Alternatively if you loved the feel of the place then do the best that you can in the audition and if it doesn't work out then try again next year. But remember that your gut feeling and what you think will suit you best is the only indication of whether or not to go to a school.

List of Schools

Just in case you want to do extremely thorough research here are the names of schools on the Drama UK website and also some names that you should know anyway.

ALRA – The Academy of Live and Recording Arts
Arts Education Schools London
Birmingham school of Acting
University of the arts London
Drama Studio London
East 15 Acting School
GSA – Guildford School of Acting
Guildhall school of Music and Drama
Italia Conti Academy
LIPA – Liverpool Institute of Performing arts
Manchester Metropolitan
Mountview
Rose Bruford
Royal Central
RWCMD – Royal Welsh College of Music and Drama
RSCMD – Royal Scottish College of Music and Drama
RADA – Royal Academy of Music and Dramatic Arts
LAMDA – London Academy of Music and Dramatic Arts
Bristol Old Vic
I do not recommend you apply to all of them. You should do research and narrow your focus onto a handful. More than 7 is stretching your attention too wide. I would recommend 4 or 5 but you can do more for the audition experience.

Voice

"The Human voice is the most perfect instrument of all" - Arvo Part

A Drama school is not going to expect you to have a detailed understanding of the mechanics of your voice and they will expect you to have little or no voice training. There will be no test on voice theory and the only thing they will ask you to do will be to sing or do a strenuous piece of acting.

The reason I've included a section on voice in this book is to give you some very basic exercises that will improve your voice without you having to go to in-depth with the theory.

The problems with teaching voice from a book

I have bought every single book on the subject of voice for performing. Singing books, Acting books, Theory books and voo-doo healing crystal books. They are all a really hard read.

The description of stances and exercises is very time consuming and all this information will be better explained by a professional voice expert. In order to make things simple I'm only going to give you one exercise per area so that you can begin to get the basics. These are not things you should be thinking about in the audition room. These are just exercises that I recommend you do in your bedroom in order for you to improve you voice – this will give you a slight edge over the competition.

If you want to study this subject more in depth then here are some books that I recommend you read:

- Patsy Rodenburg – The Right to Speak
- Patsy Rodenburg – The Actor Speaks
- Patsy Rodenburg – Speaking Shakespeare

Power

The Diamond

Stand normally with feet hip width apart.

Take your dominant hand and hold it out like you're going to do a karate chop.

Push your fingers into the soft tissue below your solar plexus – now make a shooshing noise like you are trying to silence someone.

You should be able to feel your stomach push out against your hand. Do around 15 short bursts of this sound and every time feeling the pressure against your hand.

(You can alternate between a shooshing noise and a pshhhh sound if you wish)

The point is that you aren't using your vocal chords but focusing on the pressure your diaphragm can make on your stomach.

Do not push anything but just naturally try and imagine you are shooshing someone who's speaking during a film.

Now take both your hands and push them into your sides just below your rib cage.

Make the shhhhing noise and notice that your sides also push out against your hands.

Now take one hand and put it below your belly button.

Make the shhhhhhing noise and feel it pushing against your hands.
This is what is called the diamond of support.

You don't need to think about this when you are acting but do this exercise whenever you can just to remind you where the support for your voice actually comes from.

If you repeat this exercise daily then you will start to build the muscles that help make your voice more powerful. The best stage actors are the ones that have such a naturally powerful voice that they do not need to push to be heard.

Relaxation

A lot of people hold tension in their throat and they have no idea that they are doing it. This is not something that you will be able to fix overnight.

What I recommend is that you lie down in a star position for 30 minutes. Spread your arms out to shoulder height, spread your legs and let them relax and put a pillow underneath your head.

Put on some music and lie completely still for 30 minutes with your arms out. I wouldn't recommend you do this on your bed because it's too soft so do it on the floor.

What I want you to notice is how uncomfortable this is. Your arms will start to go numb and your biceps are going to hurt.

Your shoulders will start to go numb and you will get the feeling that you can't feel the top half of your body.

This is all the tension that you hold in your body.

If you want to go for longer then you absolutely can, but this is not something that's going to solve the problem it's just a way for me to get you to notice how much tension you hold in your body.

The start of solving a problem is to notice it!

Articulation

You need to warm up your tongue and loosen the root of your tongue. The best way to do this is circle the tip of your tongue round your teeth multiple times in different directions – clockwise and then counter clockwise. Circle your tongue as if you're trying to clean your teeth with it. This is going to hurt.

Keep going until it feels like it burns.

I would recommend that you do that daily. It just loosens your tongue, and gets rid of excess tension.

On the day I would recommend that you use your speeches to warm up your articulation.

- Chew through your Shakespeare speech like you're eating toffee.
- Speak your contemporary speech through as fast as you can, making sure that all the words are clipped and clear.

Don't worry about performing your speech to death on the day. It's fine to go through lines for articulation and for your peace of mind but if you go full out too many times then you'll burn out.

Resonance

Some people have a habit of changing their voice without knowing it.
A lot of boys tend to push their voice down in order to sound more masculine.

Some girls speak higher than they naturally would for the opposite reason.

What I want you to do is to think about anything that you do to your voice to get a desired effect.

Do you speak a little nasally?
Do you make it sound lower than it actually is?
Do you get tense when you're nervous?

The best voices are not the lowest or the huskiest they are the ones that are natural to the speaker.

Even if you have the most nasal, highest and most annoying voice in the world I want you to go into that room and own it! Not all of us were born to be voice over artists and actually those people are probably not very cast able in a wide range of things.

Exercise:

To identify your natural voice all I want you to do is sigh.

Don't push your stomach or your throat as you do it just sigh.
A short sigh and do it a couple of times.

Now go into a chuckle.

Push the sigh on for a little more and start to chuckle to yourself.

Now add some text into the laugh

"Yeah that's funny... I can't believe that..."

Now go into one of your speeches after having a little chuckle.

It's just an exercise so don't go into the audition and do this but you need to identify the little ticks that you might habitually add onto your voice.

Conclusion

These are very basic exercises that I have given you but they are ones that will be taught to you in the first week of Drama school.

Even the pros do these every time they are about to go on stage.
The people who aren't doing simple exercises will be at a disadvantage even if that is slight.

However, the main thing that you will need to take away from this section is the start to a journey that should last your whole working life.
You need to get to know your voice better and this is the start.
Do these exercises whenever you can and keep those speeches alive and your voice loose.

Body

> "Most people have no idea how good their body is designed to feel" - Kevin Trudeau

People were not designed to live in the 21st century: we were not designed to sit for 6 hours a day and we were not designed to think in such a logical fashion.

There are two things that dominate our modern sedentary lifestyle:

- Long periods of physical inactivity
- Long periods of logical thinking.

This results in weak and tense bodies and brittle minds that have a tendency to be stuck in fixed patterns that don't deal well with social pressure.

Unfortunately this is death for an actor.

You need to have a free and open body and you need to have a mind that is flexible and able to deal with high pressure situations.

If you have to do the part of Mercutio in a 6 month run and you are not physically strong then you will burn out. If you have to do a part in the Olivier Theatre at the national and you haven't got good vocal training then 75 percent of the room will not hear you. If you have to do 4 takes of a scene where you burst into tears because of a tragedy and you don't have a replicable system then you will struggle and blow the shoot.

What you need to remember is a Drama school is not looking for a finished product. They understand that they will have to fix any problems

in front of them but the problems they see is a problem across the board so it's not something you need to worry about.

Exercise:

Stretching your neck and jaw muscles as often as you can is something that you cannot go wrong with. Just tilting your head side to side and yawning will loosen the equipment needed for speech.

Exercises I've given you for loosening your tongue is good for treating the symptom but if you have a tight throat it's probably because of all the muscles surrounding it. So I would recommend doing daily exercises of stretching your neck: front, sides and back.

Because we sit at our desks for so much of the day a lot of the shoulder, neck, tongue and jaw muscles are very tense. This is because when we are slouched our neck juts out and our shoulders are hunched which has a knock on effect on your voice.

Keep active

If you play a sport then I recommend that you do as much of it as possible. Using your body dynamically is a great way of getting the stress out that we acquire from our daily lives.

What I suggest you avoid is sitting. Watching TV or spending hours in front of a computer is death for a person – never mind an actor.

When you get into Drama school you will be moving for the majority of the day. Some schools will put you through movement / dance lessons and most will put you through some sort of physical schedule so you might as well start now.

If you do not play a sport or if you don't do very much physical activity – then start.

Start with anything:

- kick about in the park with friends
- go walk your dog
- go for a run
- do some yoga

In 2 months you aren't going to be able to fix a huge amount of problems but what you can do is get more life into your body. Being active is the best way to fix many problems that you might have in your body so start doing it now!

Mindset and Audition Technique

Attitude

Be enthusiastic – when in doubt, err on the side of enthusiasm. This is not a time to be cool and laid back.

When I was applying to Drama school I really believe that on a couple of occasions I got through to the next round simply because they could see how enthusiastic I was about Theatre. I talked about the plays I'd seen in London and I always said something positive about the main actor or about the cast. Half the reason they will take you on is because they like your vibe. You're young and you're fresh so use the natural energy you have to a positive effect and people will be drawn to you.

It is very likely that they are going to ask you about what Theatre you like, where you got the monologue or what you've seen lately. You want to go into this profession, so if you are not watching Theatre then you are behind the competition.

Popular Questions:

- Why do you want to be an Actor?
- Why do you want to come to this school?
- What's the best piece of Theatre you've ever seen?
- What's the best play you've read lately?

Make sure you have answers to these questions.

I tried to improvise these on the day and my answers did not come out well. I learnt my lesson the hard way, make sure you do not do the same.

How to act in the room

They have seen hundreds of people audition.

They know you're nervous.

They know you really want this to go well.

Before you walk in the room there is nothing more you can do but...

Enjoy it

At that point there is no more preparation you can do, if things go well then they go well if things go badly then you learn a couple of important lessons.

Before you walk in just remind yourself to be in the moment and enjoy it! I can't give you a list of what they're going to ask or whether they're going to chat with you before because every school is different. Some auditions will be a joy and some will be hellish – get used to it because they don't get any easier from here.

All I know is that if you have put in the work before hand and you are enjoying it then you will have a much better chance of success.

How to deal with nerves

A lot of people disagree on what to do before an audition. I'm going to tell you how I prepare for an audition and why and then I'm going to explain

the counterpoint argument. Whatever you think is more congruent to your vibe then I would recommend you go for that.

What I do:

What is a better state to do an audition in?

- You're nervous, you're shaking, you can't breathe or think straight, you haven't spoken to anyone at the audition and you haven't spoken to anyone all day.

- You're relaxed, you're breathing deeply, your body is open, you're chatting to anyone who's around and you've been chatting with people all day.

The big difference between the two people auditioning is that the first one is inside their own head and the second one is not.

The first one is predicting what's going to happen they're imagining what's going to happen in the audition room, if they've "got their lines right" or if the panel "will like them".

> The second one is non-judgmental and will take whatever comes their way.

This is called a flow state.

Top athletes, musicians, actors, pilots, bomb disposal experts, fighters and lovers, this is the state that they operate from. When you play sports you aren't consciously thinking put one foot in front of the other. When you shout you don't think to brace your stomach but you do it perfectly 99 percent of the time.

The problem with acting is that it is so difficult to get into this state because the situations are so contrived and the pressure is very much on! The main way to get yourself in this head space is to <u>be social!</u> This does not mean that you need to be a dancing monkey all day every day and in

the audition. You just need to get out of your own head and get out of your own way.

So what I recommend is you talk to as many people as you can before your audition:

If you get a taxi to the audition then talk to the taxi driver.
If you get a tube then say to the person next to you "I always hate it when there's silence on the tube, hello I'm..."
If you buy a sandwich half an hour before then ask your waiter how their day is going.

Call your friends on the phone before your audition!

A lot of Acting is simply <u>getting out of your own way</u> and in an audition you are either right for the part or not. All you can do is your best performance and then the rest is up to them. So what I do is just make idle chit chat with everyone I can in order to stay positive and relaxed.

The Exception to the Rule

There is one exception to this rule. And that is when you are talking to negative people.

If the person you're sitting next to in the audition is friendly and relaxed then bask in the delight of a new friend.

If they are nervous and negative. If they moan about how many times they've auditioned for this place. If they start giving you advice about what to do then politely excuse yourself and walk away. It is better to not be social than to be social with a negative person. That is the only instance where you are allowed to sit there in silence.

I remember walking into audition rooms and I would sit next to someone who would maniacally start talking to me about how nervous they were and how much they didn't think they were going to get in. I just wanted to concentrate on relaxing so this was unhelpful.

However, the auditions I enjoy the most are the ones where I casually chat to the people running the audition, I might ask some other audition applicants their story and where they've come from and then I have a little chat to the panel before I do my audition.

What Some Other People do

There are always those other people that listen to "Eye of the Tiger" on their headphones, sit in the corner with their eyes closed and try and think about the time that their dog died when they were 4 to prepare for crying.

Of course I'm exaggerating but you can always tell those people from a mile off and I'm sure the panel can as well. They may be great actors - so great that it doesn't matter – but they're not going to be very fun over the next 3 years.

That being said. If you are a very intense character or if you are a natural introvert then don't feel compelled to do things my way. If you need to maintain a level of focus or if you are one of those people that find the majority of the population irritating then plug in those headphones and zone the rest of the world out.

Ultimately it is up to you and you will gradually over time find which style suits you better and what ritual best suits your personality.

How to not forget your lines

If you are concentrating on remembering your lines on the audition day then you haven't done enough preparation. It's absolutely fine to visualize your speech and to go through it in your head prior to the audition but if you have a hint of worry in your head about lines then you are in trouble. UFC's Connor McGreggor says that:

> *"the fight is already decided before you step into the ring"*

What he means is that you do not win or lose under pressure because of what you do in the room, you win or lose depending on how well you have prepared.

There was one instance where I forgot my lines in a Shakespeare audition for a Drama school. I will never forget it because it was toe curlingly awkward. The reason I forgot them was because I had picked up the speech two weeks before. I hadn't done any work on it I had just learnt the lines and thought I could just pull it out of the bag. I cringe at the thought of that moment every time I think back to it. Unsurprisingly they didn't call me back.

My advice would be it is better to over-prepare than to under-prepare. There is an argument that you can rehearse a speech to death and lose all the life in your performance. Acting is an art unlike music or painting, you cannot replicate it using an inanimate object. A pianist may not be connected to what they are playing but they can still crack out Beethoven's 5th if they've practiced enough. In Acting you have to summon your own emotions by tricking your brain into thinking that it's real – at some point your brain is going to catch up.

However, if you follow the advice I give for preparing a speech then it's unlikely that you've mechanically done the speech 400 times in your bedroom which means that you've kept it alive. The exercises I have provided mean that you learn your lines while you are exploring the

meaning of the text. By doing this you don't learn your lines to death you learn them to life!

Many people will avoid that by thinking they will be able to "wing it" and trusting their natural talent. Or some people will over rehearse and create a piece that is as wooden as the boards they stand on. These tactics may have been able to work in the past but the competition is much fiercer today. You need to be better educated and you need to perform better. Don't learn your lines to death

Learn them to life!

What to do on the day

Make sure you have all your documents that are required. Schools may need photos of you, they may need documents and make sure you know the plays that your speeches are from and the authors. It sounds simple but everyone's been in the position where they are asked this question and they hesitate for a moment.

I would recommend being social, running through your lines occasionally and enjoying every minute of it!

What if I have to sight read?

There are some schools that require you to sight read.
I don't understand why all schools don't do this as sight reading is an indication of how well you can pick up a script and act in an audition. It is incredibly important to be able to sight read well.

So how can you improve your sight reading?

This is what I do for sight reading:

I put books everywhere. I have hundreds of books scattered by my bed, I have books by the toilet, I have books on my kitchen table and I have them on my phone.

Whenever I am eating, whenever I am defecating, whenever I am waiting in a queue or whenever I have a moment to spare I am reading.

I read everything I can get my hands on:

- Acting books
- Plays
- Business books
- Physical Cosmology textbooks (I told you I was a nerd)
- Novels
- Evolutionary Biology
- Poems
- Newspapers

In order to improve your sight reading you must improve your base level of reading competence. In order to improve your competence at any skill then the fundamental is practice!

My way of doing this is to make it easy for me to read all the time by having a book always within arm's reach. If you want to be an Actor then you must be reading ALL THE TIME!!! I cannot stress this enough. If you are not a big reader then start becoming one now.

Process - How to apply

Most Drama Schools have their own application process. You will have to visit each drama school website individually and go through their online portals. For example Guildhall have an online hub that you create an account on and then apply.

The exceptions are the Conservatoires such as RSCMD and RWCMD. They are part of an organization called CUCAS. (Which is like UCAS but the conservatoire version) You will need to visit www.cucas.com and start an application process similar to that of a University.

The actual act and logistics of applying is not the difficult part, which is why thousands of people do it. The actual bit you need to worry about is the preparation for the audition. The process is all laid out and entails mostly just typing your details in online.

What you might need to worry about and plan is...

Audition Fee

An issue with applying to multiple Drama schools is the Auditioning fees. I'm afraid there's no getting past this, you will just have to suck it up and pay it. There are some exceptions of schools that provide scholarships but the paperwork and time that they require for this isn't worth the hassle. Normally it's around 30 – 50 pounds to apply. Which means that if you audition for more than 5 Drama Schools the cost starts to mount up rapidly.

There is no point in getting into too much detail about why the fee is there, I would recommend that you priorities the schools that you want to audition for and start from the top of the list down until you run out of money.

Most of my advice for prioritizing schools is covered in the section on choosing schools.

Get a side job, ask your parents or ask friends – get the money and get to work!

A small caveat would be that I had a teacher who offered free lessons to an ex-convict who had so little money that they struggled to pay the Drama school audition fees. In the end they got accepted to the school of their choice and is still having a career in the industry.

Personal Statements

It is likely that you will need to prepare a personal statement for certain, if not all, of the Drama schools. Much like university they will be looking for you to answer certain key questions in this statement - which I will go over in a moment.

One thing which is important, and of note, is that a Drama school personal statement is not in the same context as a University's.

On UCAS when you are applying for University a personal statement is vitally important. It is similar in importance as a cover letter when sending in your CV for a job. Sometimes employers and Universities chose people for interviews simply because of the strength of their personal statement. It is often written in quite a formal manner as if you are sitting in front of a Director of the course and answering rigorous questions. I'm sure some students writing their University personal statements imagine rousing and dramatic music as they write their world changing pieces of literature. Drama Schools do not value personal statements as much. This process is not about how well you can write or how well you can talk about Acting – it's about how well you can Act! Do not lose any sleep over a personal statement it is not massively important for them.

However, that does not mean that a PS is not important - the emphasis is just different. The person that it is important for is you - the person

reading this and the person thinking about becoming an Actor. It is vitally important that you clarify your exact reasons because this might be the first time you put those thoughts down on paper.

Spend an hour thinking about:

- Why you want to be an Actor?
- Why you want to train at that school?
- What made you want to become an Actor?

If you cannot answer these questions then you are in very big trouble. You should spend a lot of time thinking about those questions and you should be prepared to answer them in person. I got asked them for every school I auditioned for.

Once you are confident that you are making the right life choices get to the word count, make sure there are no spelling mistakes and then press SEND. As I said before, don't lose any sleep over it.

This is not an exam and this is not university.

Speak from the heart, speak truthfully, don't use enormous words – just plainly and truthfully answer those two questions and that is all you need. This is an example from a friend of mine who wrote a great personal statement:

The first time my parents took me to the Theatre was to see "The Sound of Music" at the Palladium. I was 10 years old and decided to take after school classes and vocational courses from then on to become a skilled performer. Since then there has been nothing else that I have wanted to do and I have appeared in numerous amateur and Fringe productions. I am not saying this as a cliché - I truly mean it - if I cannot Act; if I am not Acting then I am not happy. To have a career doing something I love is something that I know is achievable with the right education. That is why I want to take that education further by applying to XXX.

I look forward to seeing you at the audition,

XXX

Simple, no-nonsense and to the point. Your personal statement is not going to get you a place at Drama school, your audition will. However, that does not mean you should dismiss your personal statement as an accessory. It is of critical importance that you are confident you know why you want to be an Actor. If you can answer that question then your statement will be easy and your career certainly will be smoother.

Head shots

You do not need professional headshots when you are applying to Drama school. Most of the time they will be satisfied with a passport style photo. I would recommend trying to keep costs low so I suggest paying for a batch in a photo-booth and then keeping them stashed away because they will come in handy later on.

I would not recommend buying professional headshots. Do not purchase professional headshots just to apply to Drama school! I have seen too many applicants spend £200+ on something that may affect your application 1%.

It does make you look more professional and it may slightly increase the effect of your first impression. When they call you into the audition room and look at your application they may be impressed at the beaming, wonderfully edited and professional photograph in front of them. However, that will not matter at all unless you can blow them away with your audition. Those people that spend hundreds of pounds on headshots should probably pay for an Acting class or a one on one lesson with that money instead.

They will be judging you on performance.

Focus on going through your speeches the way I have recommended, focus on being active and social and focus on enjoying your everyday life more than petty things like head-shots.

My experience

When I was applying to Drama school I had nearly a decade's worth of experience working in professional Theatre. I was a child Actor who had performed on the West End as well as in multiple productions up and down the country. I required headshots for my Musical productions as well as for my Theatre shows which meant that I was comfortable in front of a camera with a photographer.

Even I did not purchase headshots specifically for Drama school
That isn't because I didn't need them. By the time I was applying to Drama school I hadn't Acted in a professional capacity for a while and needless to say puberty had changed my face beyond recognition. There is no way that I could use my old headshots which meant I was presented with multiple choices.

Should I use my old and out-of-date headshots?
Should I purchase new headshots?
Should I save on money and effort and focus more on the Acting preparation by doing the least amount of admin work possible?

Luckily I chose the third option and that is the option I recommend for most people to follow. They aren't expecting you to be polished and slick business-savvy Actors at this point. All the panel wants to see is that you are talented, dedicated and willing to work with what they give you.

The Exception

For those of you who are already professional Actors or have already got high quality and industry level headshots - use them.

It would be foolish to not include them in the application when they are necessary. If you have a batch hanging around then there is no harm in using 5 for Drama school applications. It cannot do any harm for them to see that you have great headshots.

Not to harp on the same point but in any other circumstances do not pay a huge amount of money for headshots. Save your money and save the effort, there will be plenty of time to blow headshots on overpriced photographers.

What's going to happen after Drama school? - Big picture

"This above all: To Thine own self be true!" – Polonius

This is perhaps the most important chapter of all. Drama school, although a path I recommend, is not the only road that leads to success as an Actor. Not only that but it is unlikely to be the biggest contributing factor to whether you "make it" or not. There have been many blinding successes from formal training but there have been many more non-starters. That is not something to dissuade you it is simply an example that formal education does not equate to as much as people will have you believe. Ultimately it is down to your character and your tenacity that will be the most influential factor in your success. A lot of your teachers will try to persuade you that grades are incredibly important in life but after leaving school I started to question that. I started to realize that it is the qualities that we assign ourselves that make us who we are: honest, determined or cowardly.

That being said what happens after you have graduated from Drama school?

Often people will lose the enthusiasm that they first felt when they started their craft when they leave formal education. When the real world bites and disappointment sets in people will fall at the first hurdle. However, this isn't a symptom that just befalls those who are in the arts. It is a trend that I notice in older individuals that they become more conservative and fearful versions of their younger selves. When we grow

older we can either hold onto that enthusiasm or retreat from it. As we get older our aspirations do not change but the amount of fear we feel gets larger and larger. Worries can bite when responsibilities mount and as soon as you are an independent adult then your wants become more complicated. My advice would be to understand where fear comes from and learn to identify its insidious characteristics.

What is Fear?

False
Evidence
Appearing
Real

A lot of the time our neurosis and our worries are completely unfounded. We live in unprecedented times of abundance. True there is a lot of things that could go wrong but pessimism is not the attitude to have when there is so much positive attributes to this world.

No doubt if you are reading this and following this path you are also facing lots of questions from your family or friends. Some might doubt whether Drama school or going for what you want is a bad idea.
Tell them it's your life.

So what if you tried being an actor for 10 years and failed? Go join the normal work force like everyone else. This is not about "making it" or "being famous" this is about building a life around something that is worth living for.

I sometimes think that if I hadn't have found Theatre then I would have no reason to live. The best friends I have in the world I have met doing what I love and the experiences that mean most to me have been through pursuing a passion. For others that passion may be monetary gain but for me it was the Art of Acting.

So whenever you panic about the uncertainty of the future or you envy those friends of yours who have a stable job and work in an office just remember: To thine own self be true! Go for what you want even if it's the road less travelled.

"Everyone gets the journey but not everyone gets the lesson" – T.S. Elliot

"Not all those who wander are lost" – J.R.R Tolkie

Jobs

"Do you know what Job stands for?... "Just over Broke!"" – John Lee

There is a great quote from a casting Director that I had an audition with and he said: "The secret to making acting a success is to have a secondary job that you love!"

For a lot of Actors just starting out they need a job that is flexible in order to go to auditions. You can't have a full time job in an office because your boss won't be too pleased if you suddenly announce that you are taking a morning off for an audition.

A lot of the time Actors work in hospitality, recruitment or work part time in a restaurant.

The difference that I see in the Actors that make it in this industry is that they find a job that offers them flexibility but also fulfils them. That may be because they earn great money or it is a very sociable job but you need to start thinking about what jobs out there fit this criteria. For a time I was a pianist and used to earn money by doing gigs in restaurants. I wasn't acting at the time but that is an example of a fantastic job that would sustain me whilst going to auditions.

Acting is never done in isolation and it may take several years before you get the result that you want. All-in-all you have to cover all the bases in order for you to give yourself the best shot. Find that job that offers flexibility and fulfilment. Honestly, that will be more important than your Drama school Degree. A three year vocational training doesn't pay the bills.

Additional Help

As I mentioned in the introduction, this book was commissioned by www.howtodrama.com who are a company dedicated to helping people get into the Drama School's they want. There are also free articles which have been carefully researched and written in order to get the best advice out to those people who have the appetite to learn.

If you have any questions and any feedback for this e-book then please get in contact. If you enjoyed this book then please leave a review on Amazon or on the website as it really helps spread the message and get us out there to more people.

I would encourage you to seek out help from Acting teachers, mentors and also professionals themselves. For people just starting out there is a lot of sympathy and love that can be found.

I wish you luck and hopefully in the future we shall meet on a film set or on the boards of a rustic Theatre.

Break a Leg

Further Reading

Drama Theory and Shakespeare
- Shakespeare on Toast – Ben Crystal
- The Empty Space – Peter Brook
- Three Uses of the Knife – David Mamet
- True and False – David Mamet
- The Actor and the Target - Declan Donnellan
- Shakespeare advice to the players

Miscellaneous
- Impro – Keith Johnston
- Impro for storytellers – Keith Johnston
- Respect for Acting - Uta Hagen
- Presence - Patsy Rodenburg
- An Actor Prepares - Constantin Stanislavski

Personal Favourites
- The Excellent Audition Guide - Andy Johnson
- Shakespeare's Words - Ben Crystal
- The Actor and The text - Cicely Berry
- **Performing Shakespeare: Preparation, Rehearsal, Performance - Oliver Ford Davies**

"Speak the speech, I pray you, as I pronounced it to you, trippingly on the tongue. But if you mouth it, as many of our players do, I had as lief the town crier spoke my lines. Nor do not saw the air too much with your hand, thus, by use all gently, for in the very torrent, tempest, and (as I may say) whirlwind of your passion, you must acquire and beget a temperance that may give it smoothness. O, it offends me to the soul to hear a robustious periwig-pated fellow tear a passion to tatters, to very rags, to split the ears of the groundlings, who for the most part are capable of nothing but inexplicable dumb shows and noise. I would have such a fellow whipped for o'erdoing Termagant. It out-herods Herod. Pray you avoid it. Be not too tame neither, but let your own discretion be your tutor. Suit the action to the word, the word to the action, with this special observance, that you o'erstep not the modesty of nature. For anything so overdone is from the purpose of playing, whose end, both at the first and now, was and is, to hold, as 'twere, the mirror up to nature, to show virtue her own feature, scorn her own image, and the very age and body of the time his form and pressure.

www.ingramcontent.com/pod-product-compliance
Lightning Source LLC
Chambersburg PA
CBHW020923180526
45163CB00007B/2863